GLOUCESTERSHIRE AIRPORT
THROUGH TIME
Guy Ellis

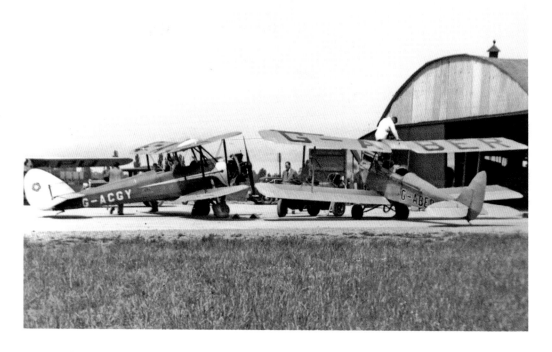

Above: Down Hatherley airfield in 1932. (Dave Welch Collection)

Front Cover
Above: Cotswold Aero Club's Mrs Joy Lloyd, their first licenced female pilot, and her instructor, Flt Lt J. C. Harcombe, at Down Hatherley in 1933.

Below: A Falcon 2000 departs Gloucestershire Airport in weather reminiscent of that which closed the airport for 27 days in the winter of 1940. (Dave Haines)

First published 2013

Amberley Publishing
The Hill, Stroud
Gloucestershire, GL5 4EP

www.amberley-books.com

Copyright © Guy Ellis, 2013

The right of Guy Ellis to be identified as the
Author of this work has been asserted in accordance
with the Copyrights, Designs and Patents Act 1988.

ISBN 978 1 4456 2061 9
ebook ISBN 978 1 4456 2068 8

British Library Cataloguing in Publication Data.
A catalogue record for this book is available from
the British Library.

Typeset in 9.5pt on 12pt Celeste.
Typesetting by Amberley Publishing.
Printed in the UK.

Gloucestershire Airport through Time

Gloucestershire Airport is at the heart of an important British aviation community where legendary aircraft such as the Gladiator, Britain's first jet the E28/39, its first jet fighter the Meteor and the delta-wing Javelin all-weather fighter, were created by the Gloster Aircraft Company. The airport was and still is the site of many innovations that include Rotol's variable-pitch propeller, Smith's automatic landing system and Sir Alan Cobham's in-flight refuelling system. More than seventy years later, the descendants of many of these companies still provide aviation equipment to the world.

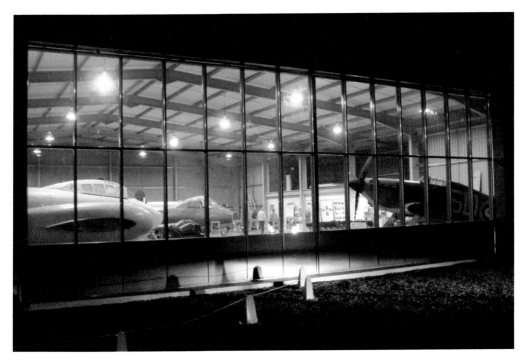

Working at night, volunteers prepare the Jet Age Museum for its preview openings in September 2013. (Steve Smith)

Down Hatherley to Staverton

Municipal authorities had been allowed to build aerodromes since 1920, but only when the government agreed to cover the costs, in 1929, did development take place. Simultaneously Arthur King and Major John Blood, partners in Westgate Motor House Limited, became agents for de Havilland aircraft. The *Citizen* newspaper in September 1930 reported Westgate would soon have a De Havilland Gypsy Moth, costing £595, on display in its showroom. King's father provided a large field on the north side of the main Gloucester to Cheltenham Road (B4063), from where Westgate could promote their aviation business. This small field became known as Down Hatherley Aerodrome, named after the nearby village.

Opened by Colonel the Master of Sempill on 26 September 1932, it was one of six new airfields listed in the *Automobile Association Register of Landing Grounds*. This detailed aerodrome facilities, local garages and hotels, and provided a message service allowing pilots to order fuel or accommodation.

The Cotswold Aero Club (CAC), which had, since 1927, been flying from other fields, moved to Down Hatherley. Businessmen in the area promoted the need for a larger municipal airfield, but local papers questioned the use of public money on facilities for an unproven transport system available only to the wealthy. In an effort to persuade the city councils that flying was the future, famous 'showman' aviator Alan Cobham staged an air display at Hatherley in May 1933. His Air Circus performed low-level flying tricks, autogiro aerobatics and wing walking and gave hundreds of people their first experience of flying. This encouraged the Mayor of Gloucester, in front of his Cheltenham counterpart, to announce plans for a joint venture to provide a large airfield in the area.

Negotiations between the councils were fraught with politics. In December 1933 Sempill flew in to address a conference, where he highlighted the importance of airfields, the suitability of the identified site at Staverton and the fact that the two towns would be by-passed if they failed to act.

In a ground-breaking agreement, the councils purchased 183 acres of land at Staverton for an Air Ministry-approved airfield, the cost of which was not to exceed £11,000. A licence to operate was granted in November 1936 and Westgate Motor House was appointed lessees and managers of the new airport.

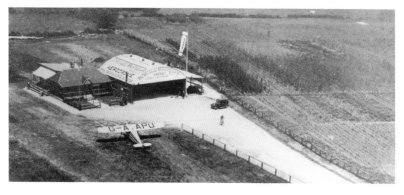

The Westgate Motor House hangar and CAC club house in 1932, with their three-seater Desoutter 1 G-AAPU. The roadway leads to the main Gloucester to Cheltenham road. (Phil Mathews)

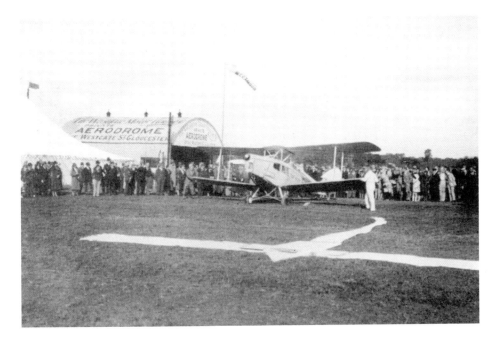

At the opening ceremony, Sempill knocked on the hangar doors with a spanner, they opened and his DH Fox Moth was wheeled out. He flew the Mayor, Alderman S. J. Gillett, and the City High Sheriff, Mr Wallace Harris, over the city and in the afternoon the Mayor became the first Gloucester citizen to fly on business from a local airfield, when he flew with Sempill to London to attend meetings. (Phil Mathews)

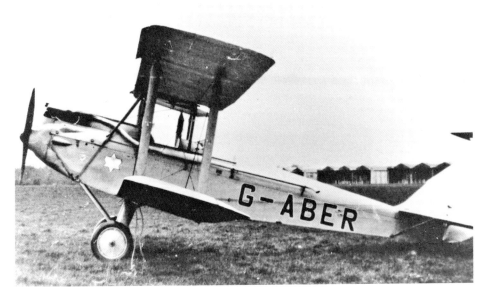

Cotswold Aero Club's first aircraft in 1932 was de Havilland DH60G Gipsy I G-ABER. Impressed into service in February 1940 as W7946, G-ABER eventually arrived at Sound City films in November, where it was dismantled and used in the construction of decoy aircraft. (Dave Welch)

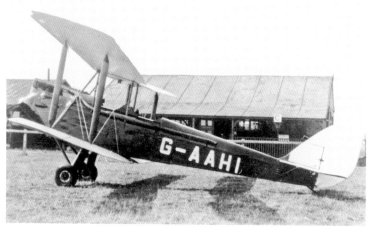

The photographer learnt to fly at Down Hatherley around the time this picture was taken in the early 1930s. DH.60G Gipsy I Special Coupe G-AAHI is still airworthy. (Jack Campbell-White via Dave Welch)

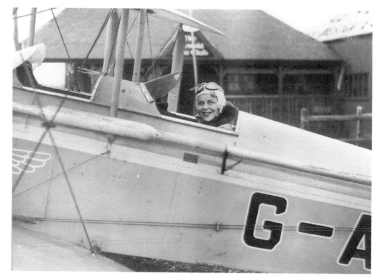

Joy Lloyd poses in G-ABER outside the Clubhouse at Down Hatherley in 1932 after becoming the first CAC woman pilot issued an A Licence by the Air Ministry. (Phil Mathews)

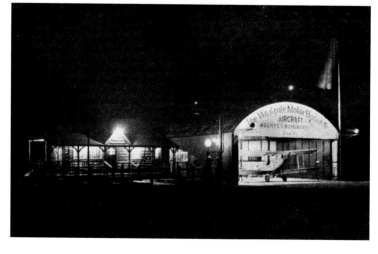

Down Hatherley at night in 1932. (Phil Mathews)

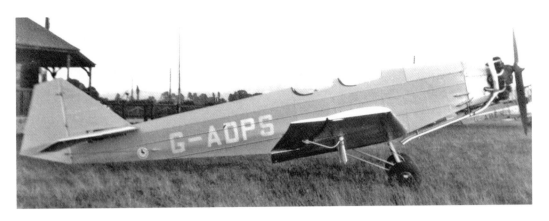

CAC's BA Swallow 2 G-ADPS in 1937. It was license-built by the British Klemm Aeroplane Company in 1935. (Jack Campbell-White via Dave Welch)

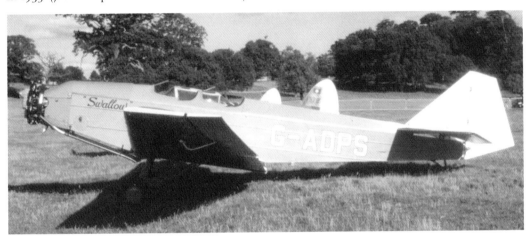

The Swallow at Woburn Abbey in 1999, still flying from a private field. (Dave Welch)

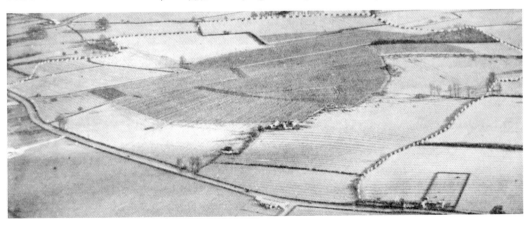

The new airfield can be seen marked out with Hatherley left centre. The site is 4 miles from each city, and fronted by the A40 it was ideally convenient for the north–south and east–west air routes. Work began to level the ground, compact runway areas and lay grass in November 1934. (CAC)

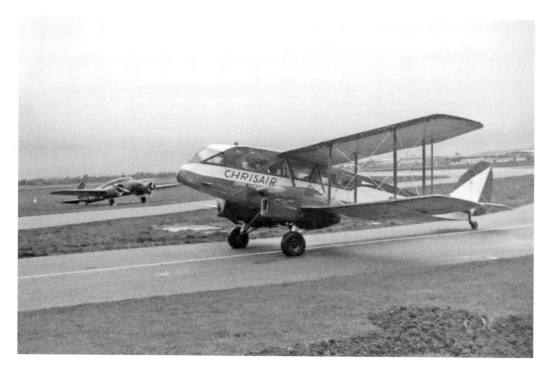

Railway Air Services provided a requested stop at Staverton, before it was completed, on its Birmingham–Bristol scheduled service. Gloucester Great Western booking clerk Harry Collier would cycle to the airport to take the tickets and act as ground control. One of the aircraft used was DH84 Dragon G-ADDI, which here returned to Staverton for this 1960s air show. (Dave Tritton)

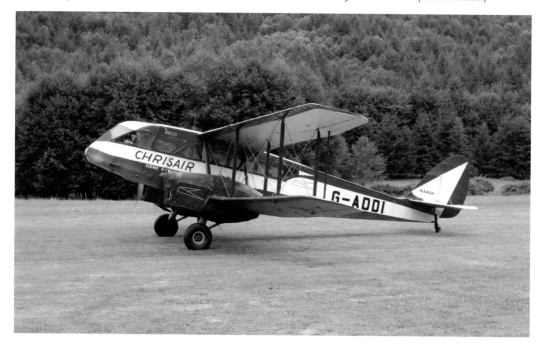

N34DH/G-ADDI in July 2013 at Kimbrel Farm Airport, Washington, USA. (Mike Kimbrel)

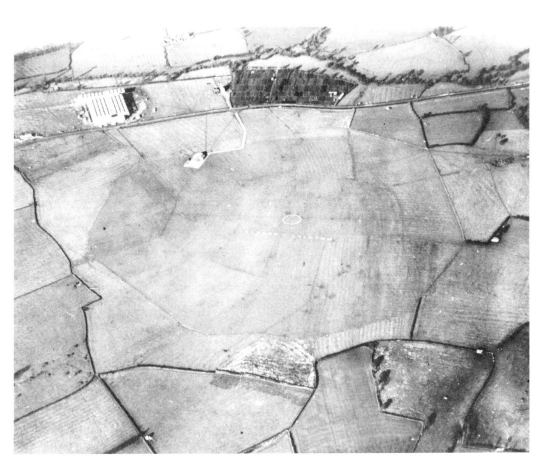

Gloucester and Cheltenham Airport, 1939. A passenger terminal and hangar have been built on the north-west side of the airfield. Across the road is the Rotol complex which dwarfs the Down Hatherley buildings, right. (Jennie Lyons)

The War Years

Air Ministry officials visited Cheltenham and Gloucester Airport in 1937, selecting the airfield for military use. CAC was appointed in May 1938 to train pilots under the Civil Air Guard scheme, then in September No. 31 Elementary and Reserve Flying Training School, operated by Surrey Flying Services, was formed. Equipped with Tiger Moths for initial training and operational aircraft such as the Hawker Hart, Hind and Audax for proficiency training, the unit remained for a year until changes in the RAF led to its disbandment.

Martin's School of Air Navigation, known as the Airwork Civil Air Navigation School, arrived in May 1939, and used six DH Rapides to teach navigation to aircrew. In August the school's name was changed to No. 6 Civil School of Air Navigation and pupils were housed in Cheltenham for a month until accommodation became available on the airfield.

Further name changes occurred on 10 September 1939, when the airport was renamed RAF Staverton and the school, No. 6 Air Observer Navigation School (AONS). By this time it was operating four Rapides, later known as Dominies, and twenty Avro Ansons.

On 3 August 1940 No. 2 Elementary Flying Training School (EFTS), escaping the difficulty of flying around the balloon barrage over Bristol, arrived as a lodger unit with their Tiger Moths.

The administration of 240 pupils and sixty Ansons had by January 1942 become 'impossible', so five flights were created: 'A' Flight at Staverton, 'B' and 'C' at Moreton Valence, 'D' at Llanbedr and 'E' at Staverton for pilot training. Simultaneously the school was renamed 6 AOS.

At the time there was a large contingent of Polish officers under training as observers or as pilots for 'A' Flight. New orders meant that new pupils were trained in Canada, while the UK schools would provide refresher courses giving crews experience in European weather and blackout conditions. Additional accommodation was provided in twenty-seven Nissen huts built in Parton Lane, Churchdown, but demand for trained crew forced the establishment of a tented camp in the orchard on Barnfurlong Lane.

Known as No. 6 (Observers) Advance Flying Unit from June 1943, it was disbanded on 12 December 1944 when lower Bomber Command losses reduced the need for crew.

The Luftwaffe 'visited' Staverton on a number of occasions. On 9 April 1940 flares were dropped – a possible precursor to an attack that took place two days later, when bombs were dropped among trees in the south-west corner of the field. Churchdown came under attack on 28 August, when eight high-explosive bombs were dropped south of the hangars and damaged a water main that affected Gloucester city and RAF Quedgeley. A Junkers 88 dived out of low cloud and dropped its bombs among greenhouses and fields half a mile beyond the airport in October. Enthusiastic AA batteries reacted to these intrusions with vigour, but they failed to down a Heinkel 111, which flew over the aerodrome twice on 14 November.

The most serious attack was on a cloudy and rainy 12 July 1941 when a Dornier 215 dropped three bombs, which killed two airmen, injured a number of others, and destroyed eight huts and an ablution block. A fortnight later an enemy aircraft flew low over the airfield and, probably put off by the intense AA fire, dropped bombs on Quedgeley, disrupting water supplies to Moreton Valence.

One of the most famous graduates of Staverton was Thomas Dobney, the world's youngest qualified military pilot. After training at Staverton he won his wings in Canada and at the age

of fifteen flew Whitley bombers in combat. Shortly after converting to Blenheim bombers he was found by his father who contacted the Air Ministry, who dismissed Tom. He re-joined in 1943, where he remained until 1950.

The last RAF aircraft at Staverton were those of No. 44 Group Communications Flight. Responsible for the control of all RAF overseas air transport movements between 15 August 1941 and 9 August 1946, they used a variety of aircraft, including the Proctor III, Tiger Moth II, Dominie, Anson and a single Douglas Boston II.

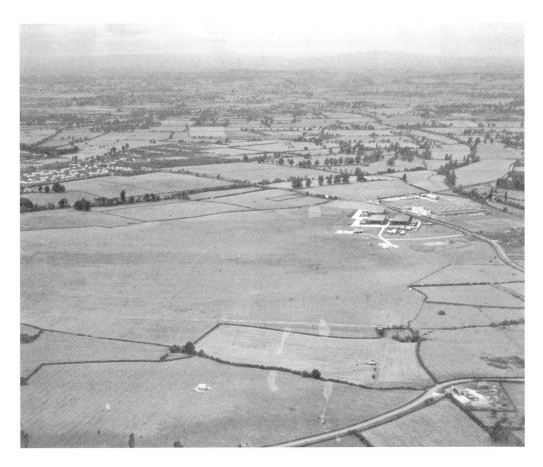

Lengthy negotiations between Westgate, the city councils and the Ministry, managed by CAC secretary Noel Goddard, resulted in a 12-year lease, in return for airfield development, which can be seen in this 1940 view. (Roger Smith)

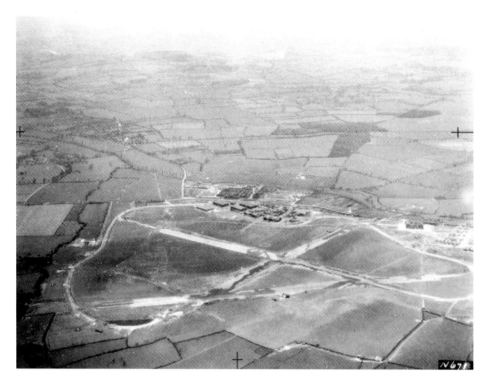

The construction of three 3,000-foot tarmac runways and Bellman hangars on the south-east side from September to November 1940 forced the lightly-built Tiger Moths of No. 2 EFTS to use a relief landing field near Worcester to which they moved permanently in April 1942. (IWM Crown Copyright)

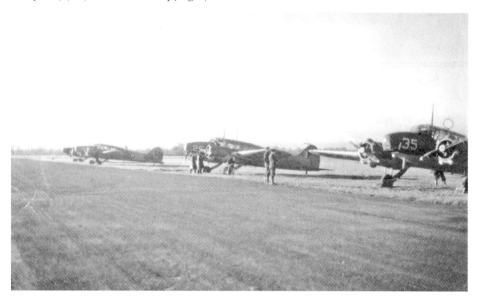

Pupils worked long hours, seven days a week and for many their first flights were a shock. The Anson smelt of rubber, dope and petrol fumes and in the air there was a great deal of noise and vibration. Avro Anson Mk I AX144 is the second right. (John Donkersley)

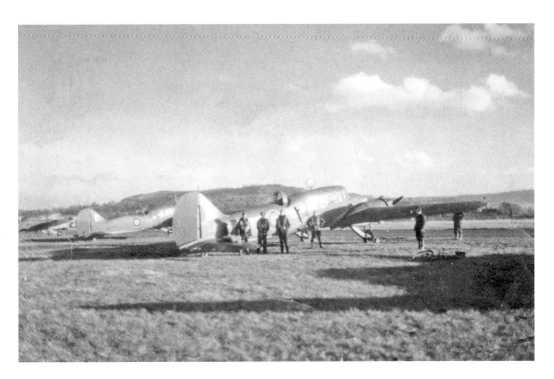

P. O. Donkersley of 6 AOS is pictured second from left in October 1942. (John Donkersley)

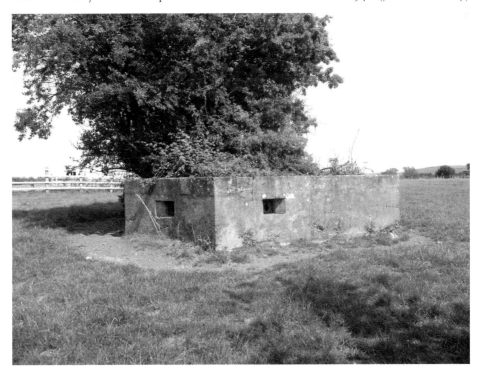

The invasion threat led to the building of perimeter defences, such as this Type FW3/22 variant blockhouse, which can be seen on the left as you drive into the airport. (Guy Ellis)

A 1940 maintenance team pose in front of an Anson. Back row second right is Jim Smith; on his left with glasses, Bill Smith; in front of him is Frank Heart; and next to him in white overalls is Frank Chambers, all members of the same family. (Roger Smith)

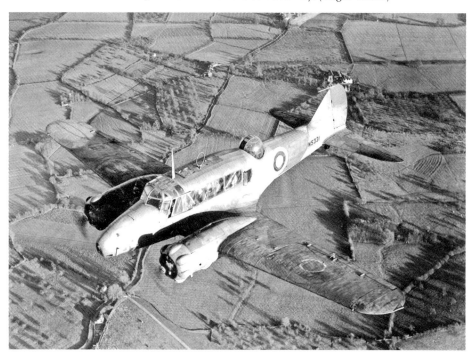

Pupils would spend twelve weeks learning about aerial photography, navigation and reconnaissance, before moving on to a Bombing and Gunnery School and finally an Air Navigation School. The direction finder and gun turret are clearly visible on Avro Anson Mk 1 N5331 of No. 6 AONS over Gloucestershire (Avro Heritage Centre)

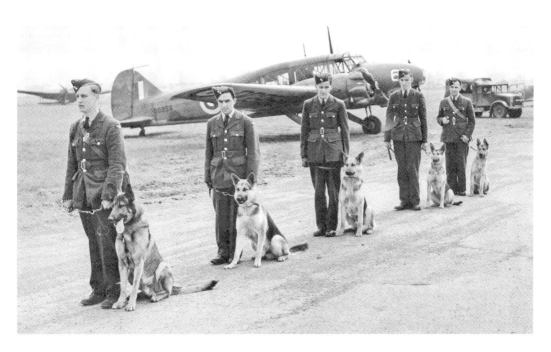

Airman M. G. Cheary remembers being transported from temporary accommodation in Churchdown to the airfield in three-ton trucks driven by WAAF drivers from RAF Innsworth, to work with their dogs on the airfield. (Stephen R. Davis)

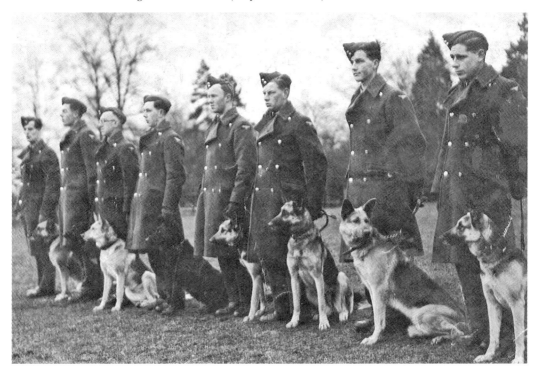

One of the first trainee handlers, Aircraftman R. F. Young, was teamed up with three-year-old Flick (No. 158), a German Shepherd bitch, who had been loaned to the RAF in 1942. (Stephen R. Davis)

RAF dogs

Flight Lieutenant Hugh Bathurst-Brown, the RAF Staverton Adjutant, received a telephone call in November 1942 offering him command of the newly formed Ministry of Aircraft Production Guard Dog School (MAPGDS). Lieutenant Colonel James Baldwin DSO, a veteran of the First World War and a dog breeder, had formed MAPGDS at Woodfold Down near Gloucester to train RAF dog handlers and relieve hundreds of men of guard duty.

Baldwin received approval to begin breeding German Shepherds, a breed chosen for their intelligence, stamina, good noses and ability to cope with extremes of the climate. A number of vacant wooden huts at Down Hatherley were turned into kennels, where suitable loaned dogs and bitches were used to breed pedigreed offspring.

The RAF Police School and its headquarters under the command of Group Captain A. A. Newbury, joined the Dog Training School at RAF Staverton in October 1946, while satellite units were opened at a rundown site in Churchdown and the former balloon repair station at Pucklechurch.

A driving school and an extremely popular Silver Band, the RAF Gloucester Dance Orchestra, were established. The band played at social gatherings and dances in the area, the top tune being 'Sussex by the Sea'! The Three Counties Agricultural Show held on the airfield in June 1947 attracted a large audience, who were entranced by the parade of forty RAF Police dog handlers and their dogs led by O. C. Flight Lieutenant Cooper to the accompaniment of the band.

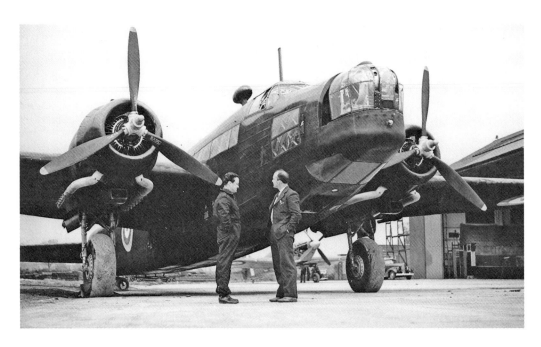

Rotol test pilot Bryan Greensted (left) and Vickers test pilot Mutt Summers with a Vickers Wellington at Staverton. (Stephen Greensted)

Propellers, Fuel and Test Beds

Wartime drew some significant companies setting up business in and around the Gloucestershire airport. These included Rotol Airscrews, Smiths Industries, H. P. Folland, and Flight Refuelling.

Rotol

Rotol Airscrews was formed in 1937 by Rolls-Royce and Bristol to develop and manufacture propellers for both companies, and an office building with a factory behind were built in 1937 on the now unused Down Hatherley Airfield.

Variable-pitch propellers were already used on multi-engine aircraft of the 1930s, but being too heavy for fighters, Rotol developed a light-weight, three-blade, constant-speed propeller which was suitable. When fitted to a Spitfire in 1940, it added 7,000 feet to the ceiling, provided a faster climb rate and better handling at all speeds.

The Flight Test Department was staffed by Chief Test Pilot Dick Morris and pilot Bryan Greensted, and was initially equipped with a Vickers Wellesley and a Gloster Gauntlet. By the end of 1939 they had a Bristol Blenheim Mark I, the first production Spitfire (K9787) and a Gloster Gladiator. After the death of Morris in a fall in the blackout conditions, Greensted was promoted to Chief Test Pilot and John (Jack) Selby Hall was employed as the second pilot. A third pilot, Dennis Dickson, was required to be able to complete the intensive test programme. The pilots worked shifts from early morning often into the night, flying a variety of aircraft, with a variety of different propellers fitted.

Often there would be over a dozen aircraft on test at any one time, requiring fitting out and removal of gauges, recorders and supporting equipment. To manage this workload, women were employed on the flight line.

Tragedy struck on 29 July 1944. While Jack Hall was testing a Spitfire Mark IX, a piece of the leading edge from one of the six blades came loose and set up a severe vibration. The contra-prop unit disintegrated and the debris damaged the tail, which broke up. Flying at 600 feet, Hall had no room to recover or bale out and he died when the aircraft came down near Boddington.

Post war there was a great deal of upheaval within the management and staff of Rotol. Bryan Greensted left to become Chief Pilot at Skyways, and in June 1947 the much-reduced Flight Test Department moved to the longer runways of Moreton Valence. Rotol acquired British Messier Limited, a landing gear and hydraulics specialist, and then in 1958 the two companies were sold to the Dowty Group.

The innovative spirit at Rotol led to the introduction of fibreglass propellers in 1968, followed by carbon-fibre units used on many turboprop aircraft. Still located on the same site, but now owned by Safran SA, the design, research and manufacturing of propellers and landing gear continues.

Smiths

Smiths Industries plc was a large global corporate with interests in aerospace electronics, medical instruments, and appliances. It originated in 1851, when Samuel Smith established his own clock and watch business in London.

The motor industry was transformed by Smiths' speedometer and the aviation world by their airspeed indicator installed in First World War RFC aircraft. Between the wars their wide range of products continued to be manufactured and the motor business grew, but Samuel's grandson, Allan, realised that aviation was the future.

With government help, Smiths moved to Cheltenham, away from the dangers of war. Later restructuring in 1944 resulted in four subsidiaries being formed, one of which was Smiths Aircraft Instruments.

From 1935 Smiths had fitted their aircraft with their products as sales demonstrators. The flying operations, known as Smiths Development Flight, moved to Staverton in 1953, where the fleet was very busy, with more than 100 demonstrations flown by the Dakota alone. After having spent six years fully engaged in sales tours abroad, a Miles Gemini G-AKHY was transferred to Staverton. More modern aircraft were acquired and the three pilots shared flying duties, while nine engineers maintained an enviable rate of fleet serviceability.

Of the many projects and systems Smiths developed, the most influential was Autoland, the automatic blind-landing system used during approach, touchdown and even a roll-out. What is now a common procedure was first performed by a Hawker Siddeley 121 Trident on a scheduled passenger service on 10 June 1965.

The entire programme was to suffer only one accident: the loss of G-APAZ on 27 March 1963. The flight check in progress required a single-engine approach and overshoot. Three miles from Staverton, at a height of 600 to 700 feet, the aircraft banked to the right and the pilot reported a total engine failure. Investigations indicated that instead of restarting the port engine, one of the crew had selected the 'cut-off' switch for the starboard engine. With no power, G-APAZ lost height and crashed into a house on Tuffley Avenue, killing the crew Russ Palmer and Kelston Thomas.

Rising costs, practicalities and technological developments forced the closure of the Flight in October 1969. Systems were so complex that inflight testing was insufficient, while computer simulation allowed tests to be carried out more efficiently in laboratories.

Folland

Former chief designer of the Gloster Aircraft Company, H. P. Folland founded Folland Aircraft in May 1937 to make, under subcontract, parts for Bristol Blenheim and Beaufort bombers, the rear section of all Spitfires, and also parts for DH Mosquitos and Vickers Wellingtons. To avoid

air attacks as components were manufactured in Cheltenham, Folland moved from Hamble to Staverton at the end of 1940, sharing a hangar with 6 AONS.

The company's first aircraft was the 1940 Folland Fo108, designed and built to meet the Air Ministry Specification 43/47 for a flying engine test bed. It was generally known as the Folland 43/47 or by the nickname 'Folland Frightful', due to its unusual appearance. Twelve of the large, single-engined, low-wing monoplanes were built. The crew comprised a pilot and two observers in a large cabin with complete instrumentation for monitoring engine performance in flight.

Five aircraft were lost, one over Staverton on 19 May 1942. Gloster test pilot Michael Daunt, flying P1777, was conducting diving trials up to 400 mph with a Bristol Centaurus Ce-1M engine; on the fourth dive the port tailplane spar failed and the aircraft broke up. Daunt parachuted, to land near the officers' mess on the north-west side of the airfield.

Engine testing still takes place at the airport, where Summit Aviation operates a fully equipped gas-turbine engine test facility.

Flight Refuelling

In-flight refuelling had been experimented with since the 1920s, but it was pioneering British aviator Alan Cobham who developed the 'grappled-line looped-hose' system. It was complex but it worked and was a great deal safer than any other method.

Concerned that their base at Ford Aerodrome, Sussex, would be attacked by the Luftwaffe, Cobham moved the operation to Malvern and selected Staverton for the flight work. It was here that eighteen-year-old Patricia Harvey first reported for duty in 1942 as the only draughtswoman on the staff. She arrived in hat, gloves and stockings, presented her portfolio of work, was asked if she could do *The Times* crossword and was then put to work with the men.

Draughtsmen generally flew on the tests they were working on, but being under twenty-one Miss Harvey was not allowed on test flights. Having turned down a flight previously, she was determined to prove she was not 'chicken' and sneaked into the rear turret of a Whitley bomber that pilot Charles Barnard was about to test. At height her flimsy clothes were no protection against the cold. When they landed and she emerged frozen stiff, Barnard rushed her home to recover.

Flight Refuelling carried out a wide variety of research for the Ministry of Aircraft Production, including the development of thermal de-icing and in 1942 bomber/fighter towing combinations for long-distance delivery of fighter aircraft.

A Hawker Hurricane V7480 Mk I, converted to Mk IIA, was fitted with hydraulically operated Malcolm towing hooks on the outer wings and a tow which consisted of a hemp rope, connected to a 200 foot steel cable shackled to a towing bridle some 15 feet in front of the Hurricane. Tests were conducted behind a Wellington IC fitted with a towing frame in place of the tail turret.

Other tests were conducted with a Wellington III and a Spitfire IX with hooks on the cannon mountings and fitted with a Rotol fully feathering airscrew. The project was abandoned when it was found that the fighter engines became too cold to restart reliably. In-flight refuelling was of

little interest to the Air Ministry, until plans were made to develop a Very Long Range bomber force, known as Tiger Force, to attack Japan with 500 Lancaster bombers and 500 tankers. Tests were successful but operational difficulties, problems with overloading and the imminent delivery of the more advanced Avro Lincoln terminated these plans. Trials continued at the Bomber Command Development Unit during 1945, with Lancaster tankers ND574 and ND843, and receivers ND793 and ND991. In June 1948 Flight Refuelling left Staverton to begin 30 years of operations at RAF Tarrant Rushton.

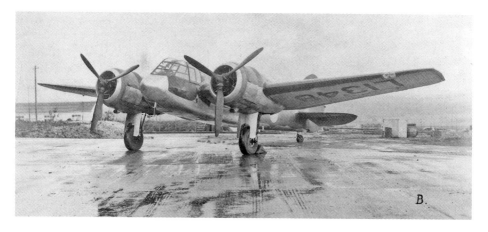

This modified Bristol Blenheim Mark I L1348 fitted with Rotol constant speed propellers was used in trials from Staverton in 1939 to develop a fast Photographic Reconnaissance platform. The top speed of 294 mph was ultimately no match for a Spitfire. (Crown)

The Duke of York inspecting a Handley-Page Halifax Mk V, fitted with reversible propellers for short landings. Pilots would position the aircraft nose-on to a hangar and then climb aboard, start up and slowly reverse in front of a stunned audience. (Stephen Greensted)

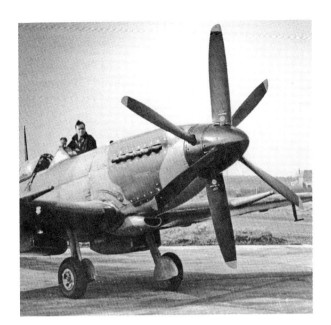

Bryan Greensted with a Spitfire
Mark VIII, converted in 1944 to
a Spitfire Mark XIV, fitted with
a Griffon 85 and a Rotol six-
bladed contra-propeller. (Stephen
Greensted)

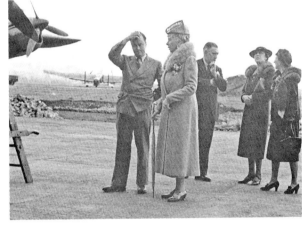

Her Royal Highness Queen Mary
standing beside a Handley-Page
Halifax Mark I, fitted with Rolls-
Royce Merlin XXII engines during
her visit to Rotol on 3 May 1943.
(Stephen Greensted)

Danish Air Force C130 B-536
loading propellers in 2006.
(Dave Haines)

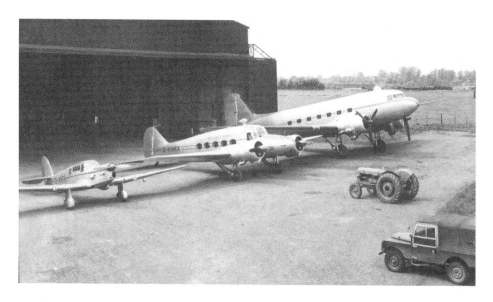

Smiths Instruments 1956 fleet. Percival P34 Proctor 3 G-AHFK/LZ768 was purchased in April 1946 for European sales tours. After it was sold in April 1958 it won the King's Cup air race but by 1964 it was derelict at Nairobi, Kenya. A more suitable demonstration aircraft, Avro 19 Series 2 G-AHKX, was delivered in 1947 to Luton, moving later to Staverton. Today it flies with British Aerospace at Woodford. Douglas DC-3 G-AMZE was supplied in 1953 by the Ministry of Supply for the development of a military version of an electric autopilot, was purchased by Smiths in 1958, sold in 1961 and broken up at Burnaston, Derbyshire, in February 1964. (Smiths)

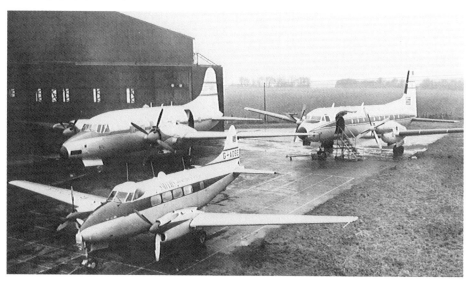

The 1964 fleet. G-AOSE DH 104 Dove 6 purchased new in June 1956 as a demonstration aircraft and then sold to Precise Surveys in January 1970. G-APAZ/WF415 Vickers 668 Varsity T1 replaced the Dakota in May 1957 and was tragically lost on 27 March 1963. In October 1963 AVRO 748 Series 1 G-ASJT became the primary development and sales aircraft fitted with all the latest Smiths products, while retaining twelve passenger seats at the rear. It was sold in January 1970 to the Royal Aircraft Establishment. (Smiths)

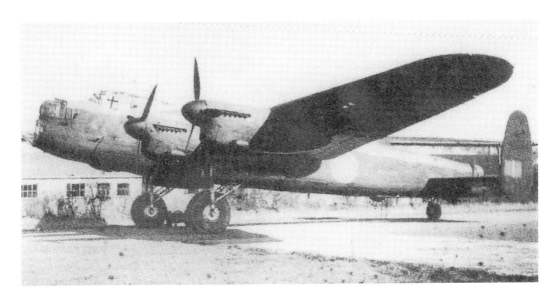

The trials for the Tiger Force took place in November 1943 with the prototype Lancaster tanker PB.972 and receiver ND.648, pictured at Staverton, proving that refuelling could be successful at an airspeed of 160 mph, above or in cloud and at night with an average fuel transfer rate of 100 imperial gallons (450 litres) per minute. (Avro Heritage)

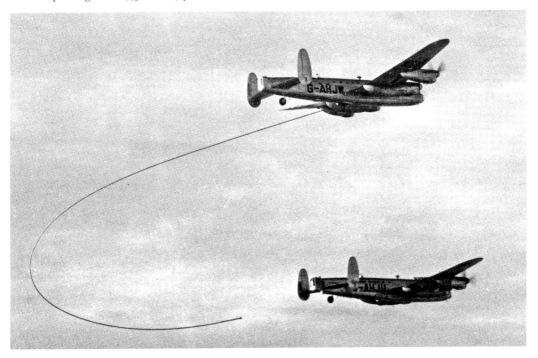

Lancaster B.Mk.IIIs (LL809, LM681, LM639, ED866) registered as G-AHJT to G-AHJW were supplied by the Ministry of Supply to Flight Refuelling in April 1946 and were converted at Staverton into two pairs of tanker and receiver aircraft. They were then used to perfect the looped-hose aerial refuelling techniques, demonstrated here by tanker G-AHJW (top) and receiver G-AHJU. (Alan Scholefield)

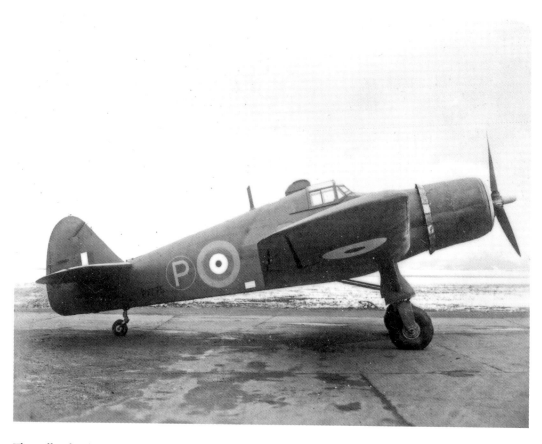

The Folland 43/47 fleet undertook valuable test programmes with a variety of engine installations and versions such as the Napier Sabre, Bristol Hercules and Centaurus. Here P1775 is fitted with a Bristol Hercules VIII engine. (Jet Age)

Guns to Butter

In the immediate post-war years there was very little management and control at Staverton. The airport was brought back to life when Murray Chown, of Murray Chown Aviation, took over the management in 1952 and introduced scheduled services to the Channel Islands. He piloted a DH Rapide G-AIYP, while his wife Gina managed passenger services.

The following year Cambrian Airways took over management of the airport under Captain Ronnie de Wilde. Although only nine aircraft were based at Staverton in 1954, private flying was increasing, while Cambrian developed their passenger services to a point that required the opening of a control tower and new passenger terminal complex.

By 1957 Staverton could claim to be the centre of Gloucestershire aviation. There were three flying schools: Cheltenham Aero Club, with an Autocrat, an Aiglet and a Miles Messenger; Cotswold Aero Club, with an Auster, a Miles Monarch and a Tiger Moth; and the Rotol Flying Club, with a single Auster. In addition, Smiths continued to operate an active test flight programme.

The growth of larger airports such as Bristol meant that Cambrian terminated the Staverton service. Smiths Instruments took over airport operations during business hours in 1958, while evening and weekend ground control and the emergency services were managed by Cheltenham Aero Club. Over time all the clubs provided these services on a voluntary rota basis.

The growing chaos, near misses and occasions when the runways were used as racetracks meant that in 1962 the two city councils decided to take direct control of the airport and appoint a manager, Mr R. F. Darby (the incumbent estates officer), and a senior flying controller, Mr W. A. L. Johnson, from Smiths. Darby became one of the longest serving airport managers in the country, who was proud of the emphasis on light aircraft, recreational flying and instruction.

The opening of the M5 from Strensham south to Bristol in 1970 made the airport more accessible, increasing the air traffic already attracted by the installation of a Decca radar system in 1969. By the mid-1970s 1,800 people were employed by the airport and the seventy businesses based on the site.

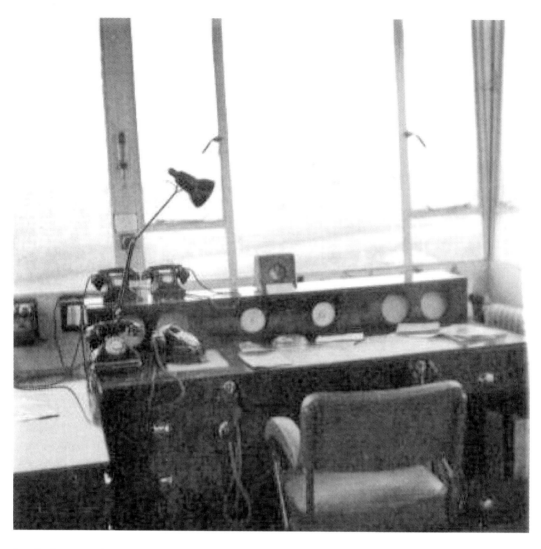

Inside the Control Tower in 1956. (Roxy Base)

The Bachelors, Ireland's
first boy band, with
Eddie Faulkner
examining an Aldis lamp
when visiting Staverton
while on their 1962 tour.
(Eddie Faulkner)

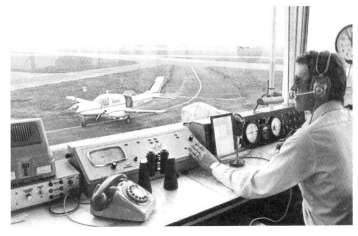

Ron Pearson on duty in
the 1970s; on the apron
is Beagle 206 G
G-AWRM. (Eddie

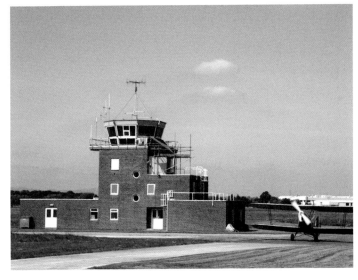

To manage increased
traffic and incorporate
new technologies a
new control tower
complex was built in
1981, consisting of a
radar room, workshops
and the control tower.
(Tiger Airways)

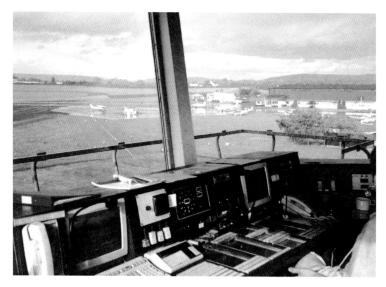

An early 1980s view from the new control tower of the terminal, middle, with SE1 an original wartime hangar on the right. (Lavina Holmes)

Continuation of the view – SE1 (left) and SE2 wartime hangars are prominent. (Lavina Holmes)

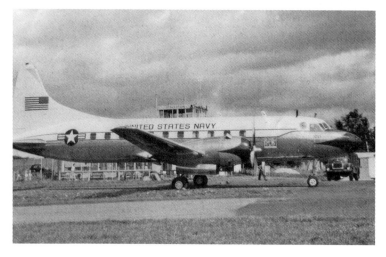

US Navy Convair VC-131F 1021 on a proving flight into Staverton in 1960 in case it was called upon to replace the normal RAF Devon liaison flight. (Eddie Faulkner)

In 1960 Handley Page demonstrated their Dart-powered HPR-7 Herald 100 G-AODF unsuccessfully to Derby Airways. (Eddie Faulkner)

Staverton was the scene of the first attempt at mass hypnosis from the air, in August 1963. Malcolm Payne flew at 1,500 ft while Mr Henry Blythe, using a radio, talked to the audience in a field below, where three fell into hypnotic trances. (Malcolm Payne)

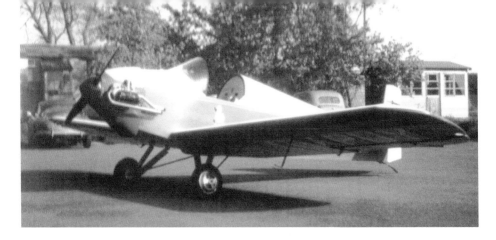

1959 Turner KFW Druine D.31 Turbulent G-APUY in the early 1970s. The building on the left is part of the CAC building and the hut on the right was the HQ for Cleeve Flying Group, the old Smiths Flying Club. This hut still exists in a garden in Churchdown. (Eddie Faulkner)

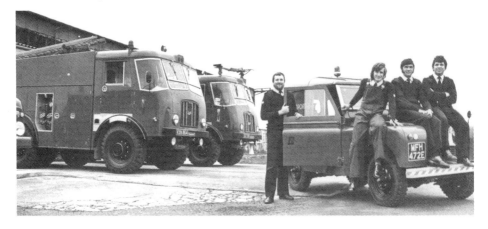

The early 1970s fire crew with Thorneycroft appliances: from left, Steve Saunders, Peter Ellis, Tom Hulland and Chief Gerrt Johnson. (Eddie Faulkner)

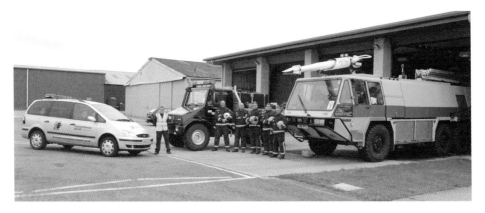

The 2013 fire crew left to righ: Airside Ops Assistant Adam Slater; Watch Manager Phil Ryan, MBE; Fire Service Manager, Ron Johnson; and Fire Fighters Marc Innes, Paul Adams and Adrian Lawman. (Darren Lewington)

King Air 90
G-BBVM in the Dowty
hangar 1976. (Steve
Wilkins)

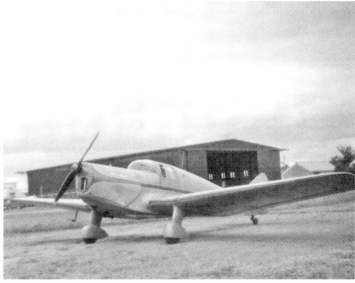

Miles M.11A Whitney
Straight G-AFGK, the
last of the type built
in 1938, at Staverton
in the 1960s. It is now
in Reynolds Alberta
Museum, Canada.
(Eddie Faulkner)

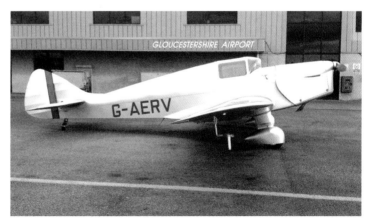

Visiting fifty years later
was Whitney Straight
G-AERV, which was
rebuilt in 2002 after
not flying for 40 years
(Darren Lewington)

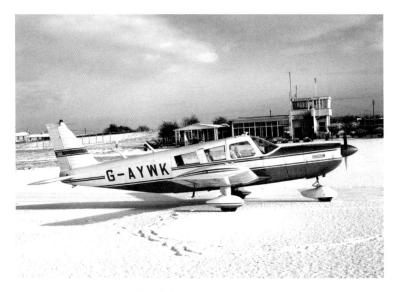

A 1970 Piper PA-32-300 Cherokee Six in the snow at Staverton, January 1977. (Keith C. Wilson)

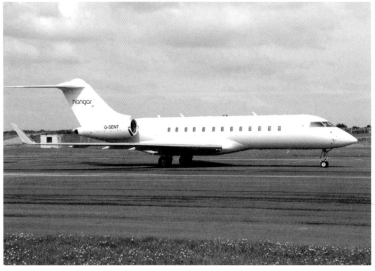

On a summer's day over thirty years later Bombardier BD-700-1A10 Global Express G-SENT taxis past the same place. (Keith C. Wilson)

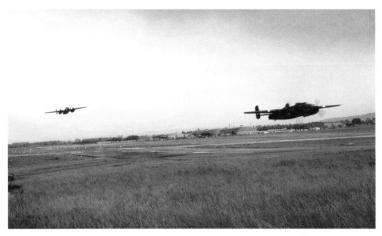

Five Second World War North American Mitchell B-25 bombers, stars in the film *Hanover Street*, re-fuelled at the airfield in June 1978. Take-off was in wartime formation. (Keith C. Wilson)

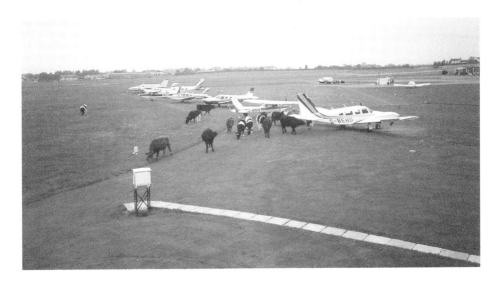

Cows can still be seen grazing outside the airport, but in the 1980s they grazed on the airfield. (Lavina Holmes)

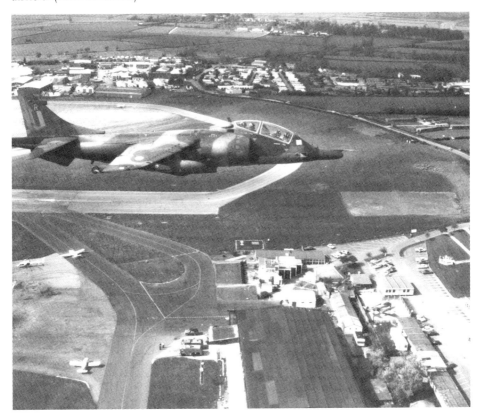

BAE Systems Harrier T4 ZB602 of RAF 233 OCU over Staverton in the mid-1980s. Directly below the Harrier is the passenger terminal and in front of this the Signal Square, which contains symbols indicating airport instructions to aircraft without radio communications, common in the 1960s. (Jennie Lyons)

DHC-7-102
G-BNGF was on a
demonstration flight
in 1987 for the Joint
Airport Committee,
promoting a service to
the Docklands airport.
(Eddie Faulkner)

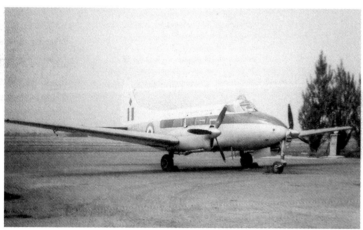

DH.104 Devon C.1
VP955 served with
the RAF from 1948
until August 1984.
The 955 Preservation
Group then operated
it from Staverton.
(Eddie Faulkner)

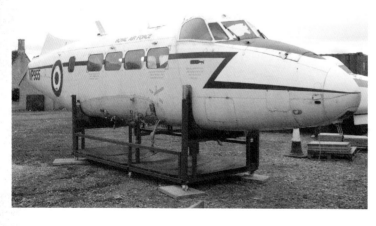

In 2013 VP955/
G-DVON is in storage
with two other Doves
in a yard in Swindon.
(Liam Daniels)

Airlines, Flying Schools and Businesses

Gloucestershire Airport has been home to a number of businesses, airlines, aviation maintenance organisations and a variety of flying schools.

Airlines

The first post-war passenger services were offered when Murray Chown Aviation was granted a licence to provide a Staverton–Cardiff–Newquay service for the 1951 season using Percival Proctors and DH89A Rapides. The service to Newquay provided onward flights to Land's End and the Scilly Isles, while another route ran from Staverton to the Channel Islands via Hurn.

Larger companies with more modern aircraft emerged to meet the growing demand. In 1953 a Welsh company, Cambrian Airways, took over Murray Chown Aviation and Olley Air Services. From Staverton they flew Rapides to Rhoose (Cardiff) and Whitchurch (Bristol). In 1967 BEA took over Cambrian and BEA was in turn incorporated into British Airways in 1976.

Derby Airlines, which became British Midland Airlines (BMA) in 1964, filled the gap left by Cambrian and when BMA withdrew in 1971, Jersey-based Intra Airways was granted a licence to operate scheduled services between Jersey and Staverton. In the 1980s and 1990s the summers were characterised by charter and special scheduled holiday flights. Capital Airlines flew Short 360s from Leeds to Guernsey with a return to Staverton, while Staverton Travel, in conjunction with AeroScope, chartered Guernsey Airlines to provide a Jersey Island, Isle of Man and Scillies service.

For a short period there were no passenger services, until Orient Air and Corbi Air began to fly a variety of aircraft to service the traditional routes. Manx2 then provided these services from 2007 until 2012, when it was announced management had bought out the company and Citywing Aviation Services took over the routes from 1 January 2013.

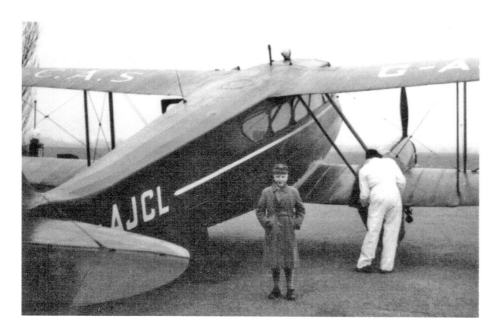

Cambrian DH89A Rapide G-AJCL, which was so regularly flown by Captain de Wilde that it was considered almost his aircraft. It is seen undergoing pre-flight inspection in Easter 1956 before flying the young lad, William, and his sister Josephine to Bristol, where they caught an onward flight to Paris. (Peter Gledhill)

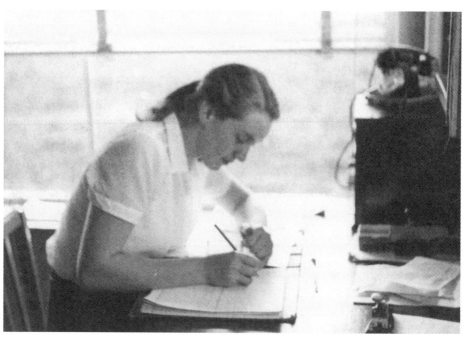

Roxy Base (Wilkinson), a licensed radio operator, worked at Staverton from 1954 to 1956 in Reservations and Air Traffic Control. She managed passengers, weighing them as well as their baggage for the C of G calculation, and often on their return booking them for their holiday the following year. (Roxy Base)

Cambrian DH104 Dove 1B G-ANMJ arriving at the terminal. (Peter Walwin)

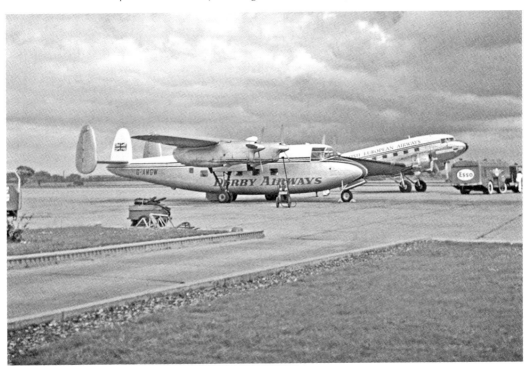

Derby Airlines offered a thrice-weekly service to the Channel Islands and a flight to Ostende, initially with DC3s and a Miles HPR.1 Marathon 1, G-AMGW, here at Renfrew. (Neil Aird)

Derby Airlines' service was so popular that on a Sunday up to five flights arrived and departed from Staverton. Passengers were bussed from Manchester and Birmingham to board Derby Airlines Vickers Viscounts and the DC4-derived Argonaut. (Eddie Faulkner)

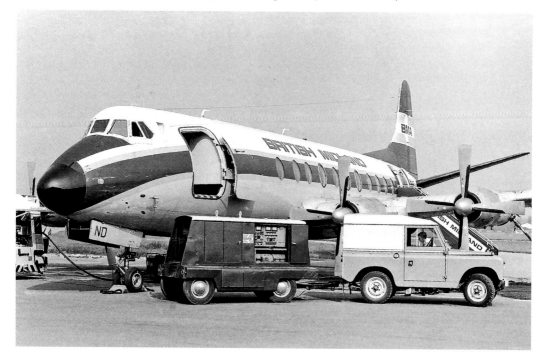

British Midland Airlines (BMA) was Derby Airlines until 1964. Here a BMA Vickers Viscount 831, G-APND, is prepared for departure. BMA exists today as British Midland International (BMI). (David J. Smith)

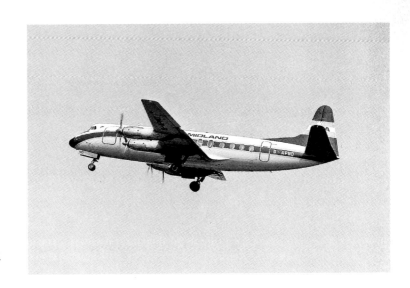

BMA Viscount
G-APND departs
Staverton. (David J.
Smith)

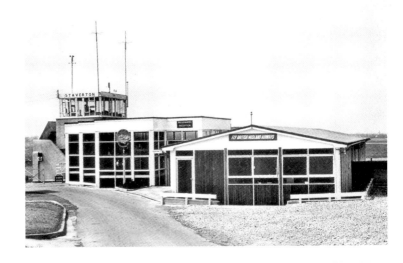

The BMA terminal
in 1970 with the
original control
tower. (Lavina
Holmes)

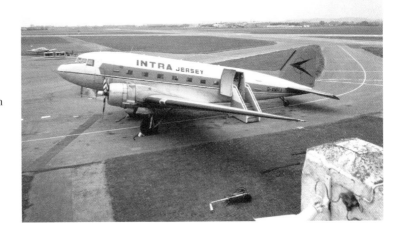

Intra flew DC3s then
Vickers Viscounts,
linking Jersey
with Cambridge
and Staverton
and a number of
destinations in
Europe. (Keith C.
Wilson)

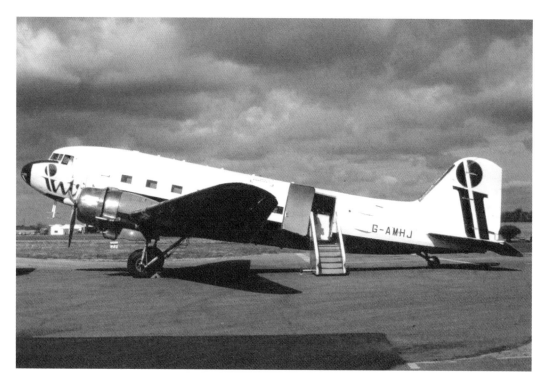

G-AMHJ in the last Intra livery scheme. (Keith C. Wilson)

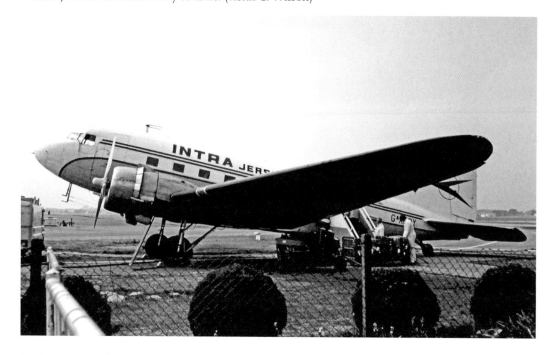

G-AMPY, pictured here at Staverton in September 1976, saw operational service in Burma during the Second World War and in the Berlin Airlift. It operated with Intra until 1980 and is now preserved and flying in her Burma colours. (Alan Scholefield)

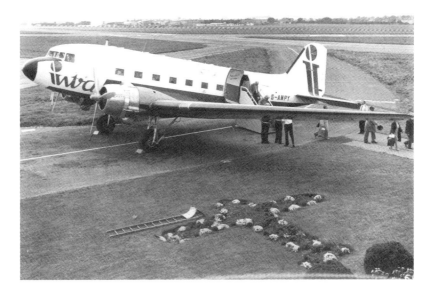

G-AMPY in the last Intra livery scheme, probably around 1978. (Eddie Faulkner)

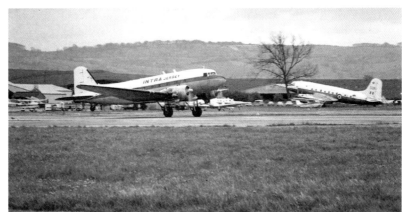

An earlier Intra colour scheme on a DC 3. (John Bell)

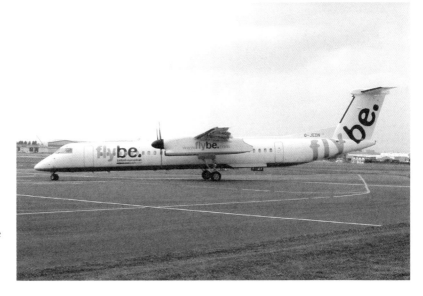

Intra is today FlyBe. DHC-8-402 Dash 8 G-JEDN was by 2013 the largest aircraft to operate from Gloucestershire Airport. (Nigel Brown via Dave Haines)

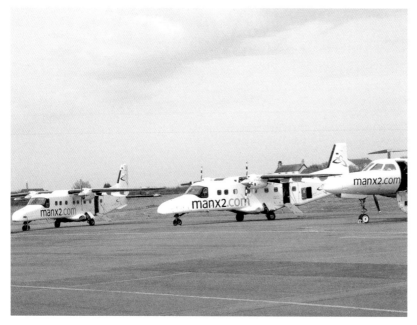

In September 2007 Manx2 began scheduled services from Staverton to the Isle of Man, Jersey and Belfast City, transporting almost 90,000 passengers. (Keith C. Wilson)

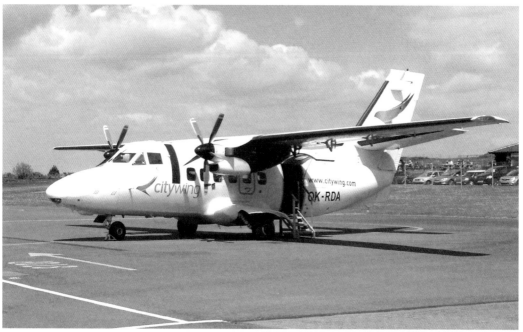

Based at the Isle of Man's Ronaldsway Airport, Citywing offers flights to Belfast, Blackpool, Gloucester, Newcastle and Jersey using a fleet of Let 410 nineteen-seat aircraft. (Guy Ellis)

Flying Schools

Cotswold Aero Club

The Cotswold Aero Club, established in September 1930 by Arthur King and Rex Walwin, moved to the newly created Down Hatherley in 1932 and the following year the club was formed as a private company.

The club owned four aircraft in February 1934: two DH Gipsy Moths, a Desoutter I and a Parnall Elf. By 1935 it had 200 members, Mr J. Northway was Chief Flying Instructor (CFI), and a Klemm Swallow was delivered and another Gipsy Moth arrived in April 1936. Shortly before the outbreak of war, a further Swallow G-AWEB and a Gipsy Moth G-AAIU were purchased.

At the September 1935 Club Rally and Garden Party, crowds were entertained by stunning displays by Rex Walwin and convergence bombing by Walwin, in the Elf, and Flight Lieutenant J. C. Harcombe, flying a Gypsy Moth.

Joy rides were flown all day in the Desoutter and there was great interest in the quiet engines and luxurious interior of the Vacuum Oil Company DH Dragon, which had flown in from Hamworth with pilot Mr J. White and a passenger, 'a well-known motorist', Mr Gordon England.

Prior to the war CAC trained Civil Air Guards and by April 1939 had eighty-three under training, of whom fifteen had obtained their A licences.

After the war, the club was revived, but with only thirty members, a Tiger Moth and an Auster. It struggled to compete with the two other clubs with more modern aircraft, and was forced to sell the Tiger Moth. To supplement the Auster, Smiths Instruments presented the club with a Miles Monarch G-AFJU in 1955.

With the death of its head, Jack Bennett, in 1964, the club was in dire straits. It was saved when on 10 May 1966 the new board of directors had delivered a new Bolkow Junior G-ATSX. The troublesome old Auster was sold and Malcolm Payne appointed CFI. Payne was the radio instructor and the club became the first organisation outside of London to be appointed an approved radio test centre. Payne's fellow instructor was John Cole, who in 1983 was awarded the Lennox-Boyd Trophy for his contribution to flying training.

Membership was at an all-time high on the club's fiftieth anniversary in 1981 and it celebrated by taking part in a large RAF display in May and with the delivery of the first new aircraft in ten years.

Since then the club has continued to maintain its tradition of a professional yet relaxed attitude towards flying and learning to fly. It is now owned and managed by Philip Mathews, who started out looking over the fence at an air show, then took on a job as the club's 'Saturday boy', and soloed shortly after his seventeenth birthday. He became a fulltime instructor in 1988, a Master Pilot and Liveryman of the Guild of Air Pilots and Navigators, with more than 20,000 hours' experience.

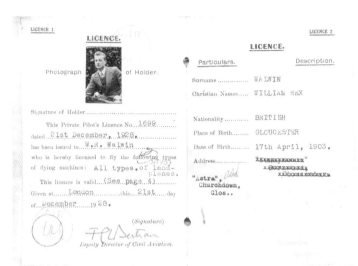

A copy of Rex Walwin's pilot's Licence. (Peter Walwin)

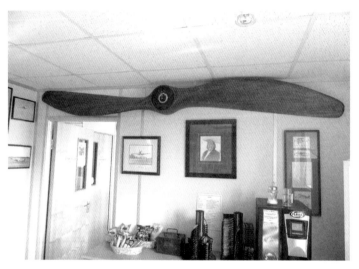

Suspected to be off a First World War de Havilland 9A bomber, this propeller decorated the original CAC clubhouse at Down Hatherley and now adorns the clubhouse at Gloucestershire Airport. (Guy Ellis)

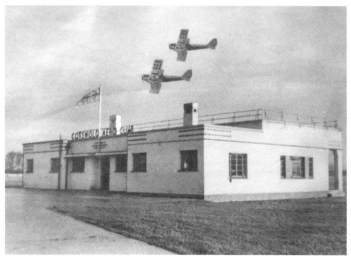

By 1937 the club was making use of the new airfield and negotiated a lease on a purpose built clubhouse. (Peter Walwin)

Auster G-ANHW was sold in 1965. Written off in 1970, the wreckage is still in storage. (Peter Walwin)

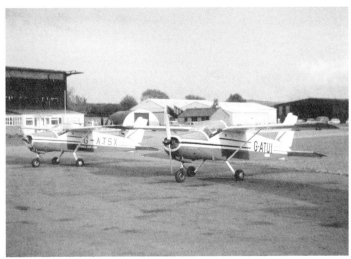

The pair of Bolkow B208C Junior aircraft that were the mainstay of CAC for many years. (Phil Mathews)

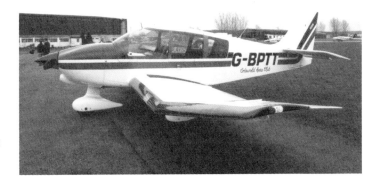

Robin R400 G-BPTT was with CAC from 1989 to 2001. (Phil Mathews)

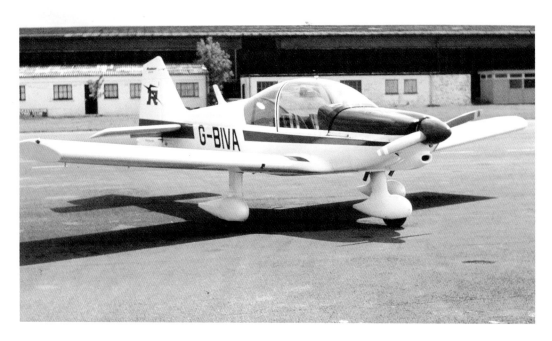

The first new aircraft in ten years was French-built Robin 2122 G-BIVA, delivered in 1981. (Phil Mathews)

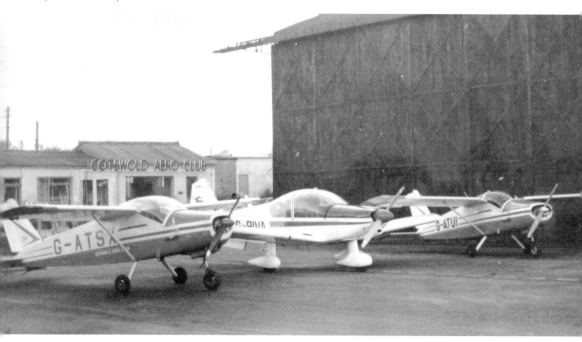

The fleet in 1981: two Bolkows and a single Robin. (Phil Mathews)

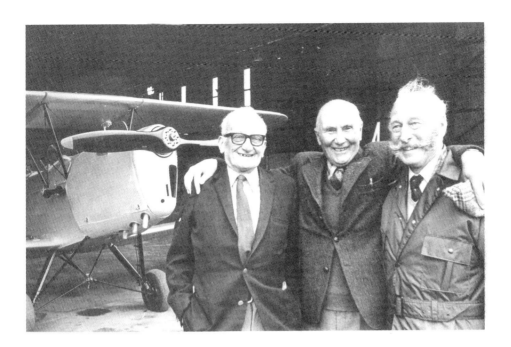

The *Citizen* newspaper ran a competition for a flying scholarship in August 1934 which attracted 110 entries. Instructors reported that women fared better than men as they followed instructions and showed an aptitude for flying. The prize was won by Eric Bettington of Hucclecote, with runner up Harry Daniels of Stroud. On 10 May 1981 they had a reunion at CAC, left to right Rex Walwin, Harry Daniels and Eric Bettington. (Peter Walwin)

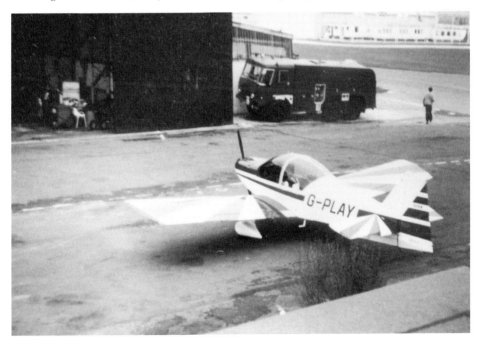

Robin G-PLAY was delivered in 1982 and at the time was the most comprehensively fitted single-seater on the airfield. (Peter Walwin)

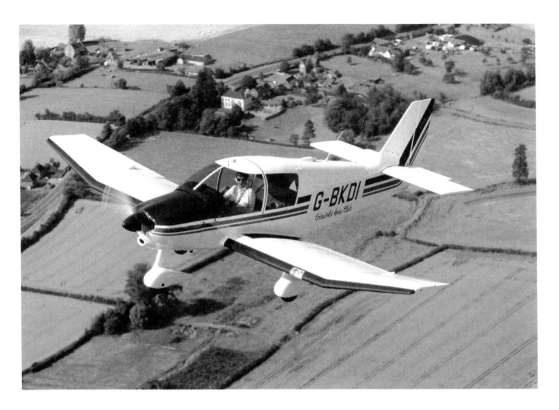

Robin DR400/120 G-BKDI in flight in 1987. (Phil Mathews)

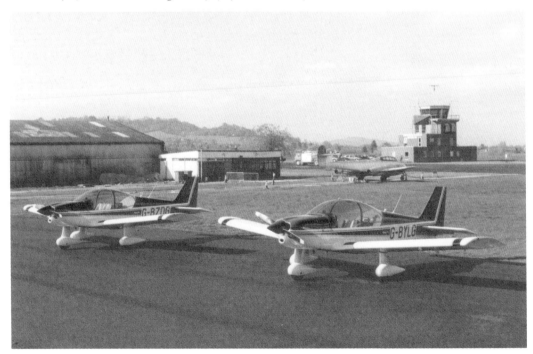

Robin HR200/120Bs G-BYLG and G-BZDG in 2000. (Phil Mathews)

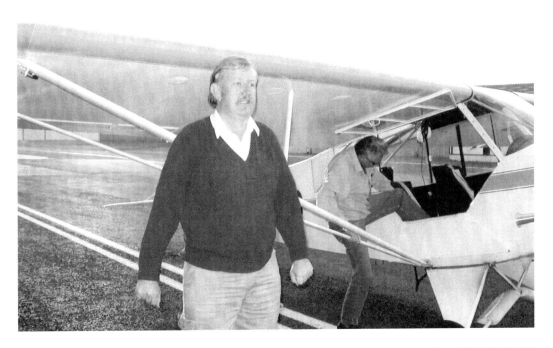

Phil Mathews shortly after having flown this 1952 Piper PA-18-95 Super Cub OY-ELG/G-OVON on an eight-hour delivery. (Phil Mathews)

The 2013 fleet: Robin R2112 G-OCAC; two Robin DR400s, G-BBCH and G-BKDJ; and a Piper Arrow, G-OMNI. (Phil Mathews)

Staverton Flying School

Staverton Flying School (SFS) was started in 1965 by L. H. 'Woody' Wood, with a single Cessna 150.

Woody, a charismatic character, joined the RAF in 1937, where he flew Gladiators before instructing on Tiger Moths with the Empire Air Training Scheme. Post-war he flew for an airline, ran a charter company and was CFI at various flight schools and chief pilot for Smiths Aviation. Of the 18,000 hours he had flown, 12,000 were spent instructing.

Keith Lyons and Charles Warner came to the rescue of a struggling SFS in the late 1960s. Keith's daughter Jennie came to do the books and by 1974 she was instructing and became the youngest woman CFI in the UK.

Jennie took over SFS in 1981 and the school became the first to provide Professional Pilot's Licence (PPL) helicopter training at Staverton. Jennie introduced 'Women in the Air' days, where three women instructors would fly up to fourteen trial flights a day. She sold the business in 2005, but it ran into problems; one of the instructors, Kathryn Williams, stepped in to save the school.

Cheltenham Aero Club

The Cheltenham Aero Club was formed in 1949 by former Central Flying School instructors to provide ex-RAF personnel an opportunity to attain commercial licences, instructor's certificates, and an instrument rating. When the University of Southampton closed its air navigation school in 1952, the club obtained all their training materials. A new restaurant, a Link Trainer room, photographic quarters and a radio room were established in two brick buildings made available by the airport management.

At the time the airport was derequisitioned, and with no suitable beacons night flying was suspended; so club members set about making their own 5 kW beacon and an angle-of-approach indicator. The club eventually closed in the early 1960s, and Skyfame took over their hangar.

Dowty/Rotol Flying Club

Established by Rotol employees in January 1945, the Rotol Flying Club shared a hangar with the Cheltenham Aero Club. Their first aircraft was a Taylorcraft Model A, purchased through subscription and with the aid of a loan from the company.

Difficult times were experienced which were reversed with the arrival of Jack Meaden. When Rotol introduced a scheme that subsidised employees' flying in 1952, an Auster J/1 Autocrat G-AHCL was selected as a more suitable aircraft. It remained with the club for twenty-one years and was replaced by a Rallye and then by a Cherokee, until the club ceased to operate in the late 1990s.

Members of Rotol Flying Club, Sept. 1954. Middle row, third left Jack Meaden and Ray Base; Sir John Evetts, Chairman of the Club, in front of the propeller; unknown, then Ken Daniell (CFI for twenty years); Capt. de Wilde (Airport Manager); Jack Bennett; Eddie Simpkins (Cambrian Engineer); and Aubrey Reeves. (Ray Base)

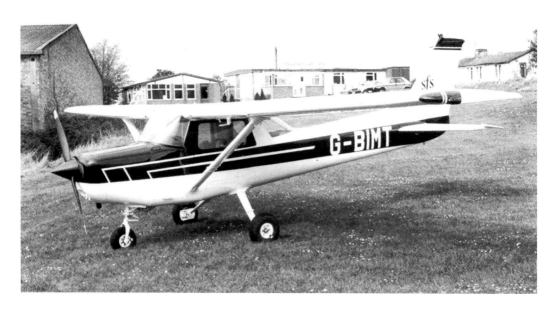

SFS moved across the airfield in December 1965 to the wartime Station Commander's office and then airport manager's office. Cessna 152 G-BIMT purchased in 1981 is shown outside the original SFS location, now known as the Flying Shack. (Jennie Lyons)

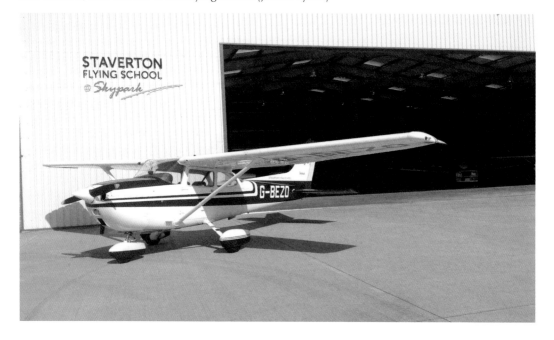

Cessna 172 G-BEZO of Staverton Flying School at Skypark outside their modern new premises on the south-east side of the airport in 2013. (Kathryn Williams)

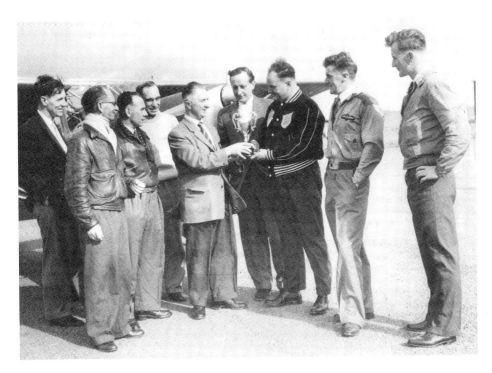

The Cheltenham Aero Club received an award for its contribution to general flying. Pictured second left with glasses is the owner of the club, Aubrey Reeves; Malcolm Payne is third right receiving the award. In the background is the club's Auster, G-AMTR. (Malcolm Payne)

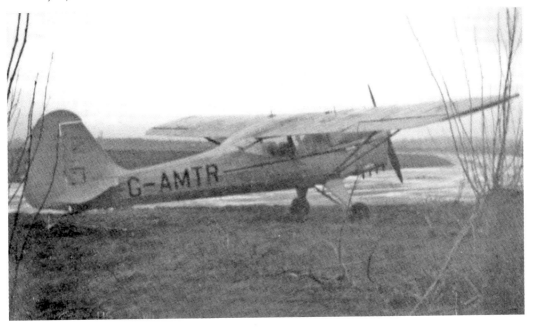

The Cheltenham Aero Club's Auster J/5F Aiglet Trainer, G-AMTR, on 9 February 1957. (Peter Clarke)

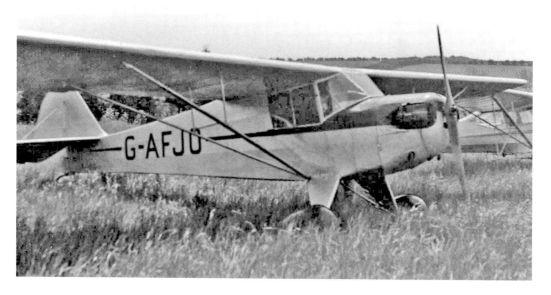

Rotol Flying Club's first aircraft in 1949 was this Taylorcraft A, G-AFJO, shown at Auster's airfield in 1951. It was written off at Staverton on 15 June 1952. (Alan Scholefield)

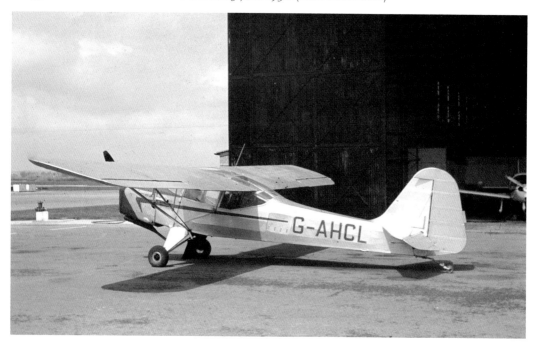

Rotol Flying Club's G-AHCL Auster was modified to a four-seater Auster J/1N Alpha with a 130 hp Gipsy Major 1 engine and a long-range tank that allowed four hours' instruction without refuelling. (Phil Mathews)

Businesses

Gloucester Airport has always been a vibrant business centre with the majority of companies allied to the aviation industry.

Flight One Air Services, formed by five former RAF members, offered a number of maintenance services from the old Smiths' hangar and operated an aerial survey service.

In 1964 Air engineers built a Rhomboidal Biplane replica for the film *Those Magnificent Men in their Flying Machines,* which was produced from pictures published in a 1911 edition of *Flight*. The non-flyer dwarfed a Tiger Moth.

Sir Derrick Bailey DFC, son of South African mining magnate Sir Abraham Bailey, in the 1960s opened Glosair, an aircraft maintenance business based on the south-east side of the airport. Glosair obtained the licence to assemble Victa Airtourers, marketed as the Glos-Airtourer, and from 1970 GlosAir was responsible for the operations and maintenance of the BN2 Islanders for Aurigny Air Services, until the business moved in the mid-1970s.

Looking very much like the famous Tiger Moth after which the company was named, Tiger Airways use the Stampe SV.4C aircraft to give people the opportunity of flying in the open cockpit of a vintage biplane.

Chief Pilot and CFI Tizi Hodson and Flight Operations Manager Chris Rollings began the company with a borrowed Tiger Moth and then leased a Stampe, the first of a brace of these ubiquitous aircraft. A Fournier RF6B-100, G-BKIF, and a Robin ATL are used for flight instruction and the Robin for solo hire.

The Colt Car Company operated its aviation division from Staverton until 1983. Their Aviation Director, Peter Turner, established Executive Aviation (EA) to manage executive aircraft on behalf of their owners. The maintenance, chartering, scheduling and crewing of these aircraft are all provided by EA, allowing the owners to concentrate on their core business while benefiting from the efficiencies of a corporate aircraft. Peter Turner has flown 150 aircraft types over fifty years and is a Master Pilot, Liveryman of the Guild of Air Pilots and Navigators, and was granted the Freedom of London in July 2013.

Bond Helicopters was founded by David Bond in the 1960s to provide crop-spraying and heavy lifting services and in the 1970s introduced the state-of-the-art MBB105 to service offshore oil rigs.

Geoff Newman, an ex-naval helicopter pilot, carried out research on the German-based air ambulance service and how it could be adapted for the UK. As was impossible for the National Health Authority to fund the service, he followed the RNLI public donation model. Bond loaned him an MBB105, fitted as an ambulance, on trial free of charge for three months. This trial was so successful that it resulted in a nationwide network of air ambulances being set up, as well as contracts for lighthouse work and offshore wind-farms.

The Staverton HQ is not only the operations hub but also provides a sophisticated maintenance centre. Sold by brothers Peter and Stephen Bond to Inaerfor in 2011, Bond continues to grow and be an important part of Gloucestershire Airport.

Specialist Aviation Services is the umbrella organisation for Police Aviation Services (PAS) and Medical Aviation Services (MAS). Established in 1984, PAS provided the first police air support unit, offering pioneering techniques that are common practice in police aviation today. A year later, MAS began operations to provide air ambulance services.

These services have been based at Gloucestershire Airport since 1991 and they continue to expand their facilities to meet the demands of both UK and international customers and provide full maintenance and modification facilities.

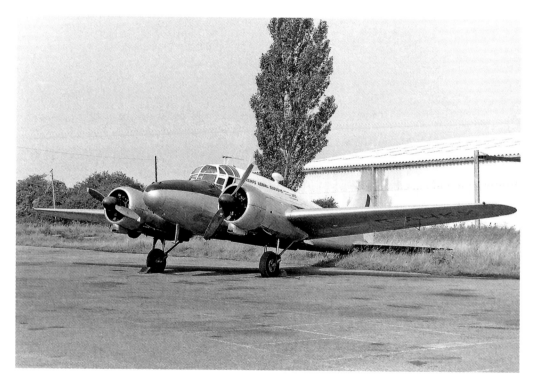

Kemps Aerial Surveys' 1946 Avro 652A Anson C19 series 2, G-AHKX, at Staverton in 1969/70. Now owned by BAE Systems, this aircraft flies with the Shuttleworth Collection. (David J. Smith)

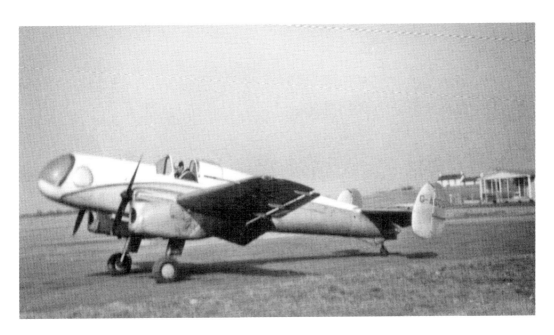

Reid & Sigrist Ltd RS4 Desford Trainer G-AGOS was developed in 1951 to investigate g-forces at low speed on a prone pilot. After tests with the RAE and then use in film work, it was purchased as a hack by Kemp Aerial Surveys. It is currently stored at the Snibston Discovery Park Leicestershire. (Eddie Faulkner)

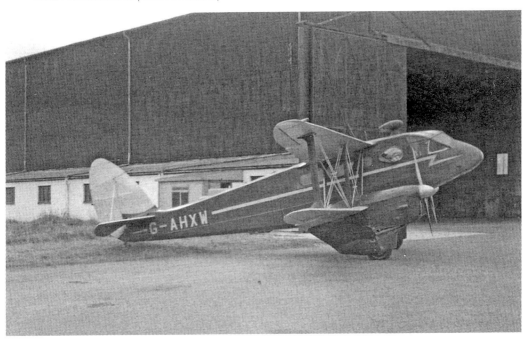

DH-89A Dragon Rapide G-AHXW was used by Precise Surveys Limited from February 1968 for aerial surveys on projects such as the M5, M62 and M42 Motorways, Seaforth Docks at Liverpool and Skipton Reservoir. She was replaced by a DH Dove, G-AOSE, in 1971. (Chris Vaughan)

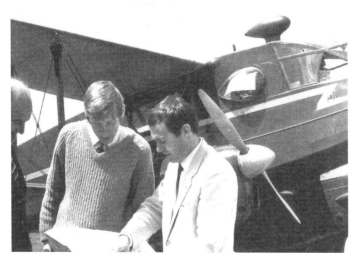

Pilot Malcolm Payne of Precise Surveys on the left discusses a proposed flight with the camera operator and navigator. (Malcolm Payne)

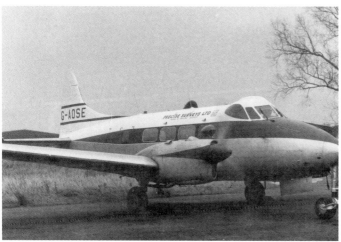

Precise Surveys' Dove 6, purchased from Smiths, was stripped of test equipment, fitted with cameras and flown on surveys recording the state of coal heaps, acreage under potatoes, and routes for various motorways such as the M5 from Weston-Super-Mare south to Exeter. The Dove was eventually scrapped at Coventry in 1974. (Malcolm Payne)

This Edgar Percival E.P.9 was flown by Precise Surveys' Malcolm Payne on aerial survey work, parachute drops and film work. (Eddie Faulkner)

Cars have also been a part of the airport, from the Cheltenham Motor Club Sprint weekends near the new Jet Age Museum to advertisements, such as this one for a mid-1960s Riley Kestrel 1100. (Eddie Faulkner)

A 1991 Mitsubishi Galant Hatchback with the company's Cessna Citation 500 as backdrop. (Peter Turner)

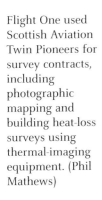

Flight One used Scottish Aviation Twin Pioneers for survey contracts, including photographic mapping and building heat-loss surveys using thermal-imaging equipment. (Phil Mathews)

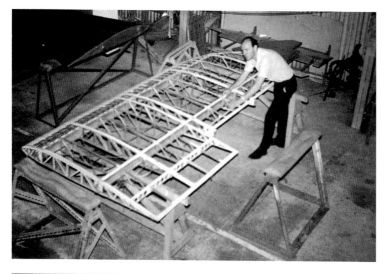

From 1970 Flight One provided hangar space for the four-year rebuild of the Shuttleworth Trust's Gloster Gladiator. (R. A. Welch)

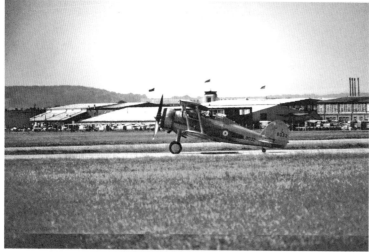

Wing Commander Martin took the Gladiator to the Churchdown end of the runway, opened the throttle and roared off into the clear blue sky. (R. A. Welch)

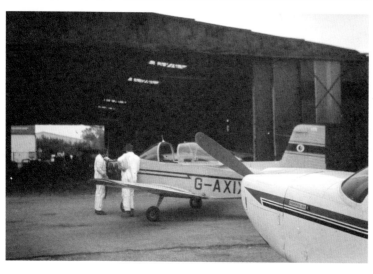

Airtourer 150 G-AXIX was assembled in September 1969 and painted in Glosair's colours, undergoing maintenance. (Phil Mathews)

The Glos-Airtourer, an aerobatic-capable two-seater, was designed by Dr Henry Millicer of GACF in Australia. Sales were slow and some airframes were stored for up to three years before re-assembly. Here a Super 150, G-AZBE, built in 1971, taxies past the Aeros hangar in 2005. (Dave Haines)

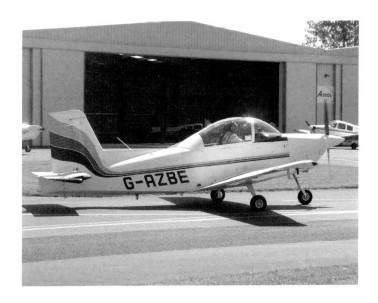

The Belgian-built Stampe et Vertongen SV.4 two-seater trainer/tourer biplane was built post-war under licence in France and Algeria and used as an airforce primary trainer. (Tiger Airways)

By 2004 Tiger had set up its own maintenance department; one of their tasks was the assembly of AT-6D Harvard G-TDJN after importation from the USA. (Tiger Airways)

Slingsby T67M MkII Firefly G-BUUF and a CAP 10 C are used for aerobatic courses run by Tizi, twice Leading Lady of British Competition Aerobatics and part of the Unipart/Skyhawks Display Team, here in the right hand seat of the Firefly. (Guy Ellis)

Tiger Airways' Stampe SV.4C G-AYCG under maintenance in a busy Tiger hangar. This aircraft flew with the Rothmans Aerobatic Team between 1971 and 1973. (Guy Ellis)

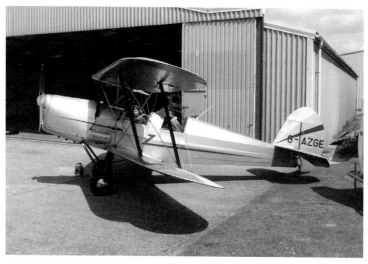

Stampe G-AZGE was modified to resemble an SE5A fighter, coded E940, in *Aces High* in 1983. Later it featured in *High Road to China*, with the fake registration G-EQHE. Meanwhile Stampe G-BHFG, built in 1945 and now under major rebuild, starred in *Indiana Jones and the Last Crusade*. (Tiger Airways)

Boeing E75 Stearman G-BSWC of Tiger Airways, used for wing walking. (Tiger Airways)

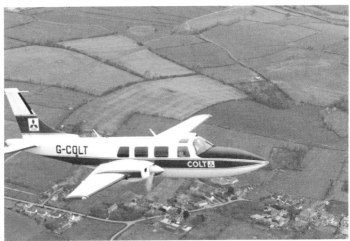

Colt Cars' first aircraft delivered in 1978, was this Piper PA-60-601P Aerostar. (Peter Turner)

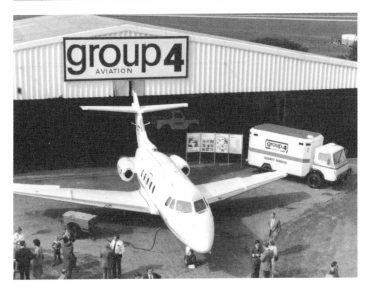

Executive Aviation managed Group 4's aircraft. Their HS125 G-FOUR is seen here at the opening of the company facility in the early 1980s. (Peter Turner)

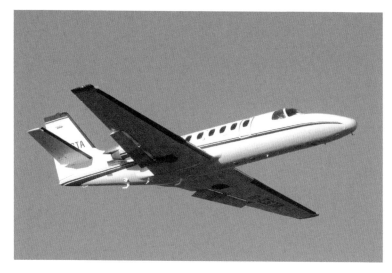

Executive Aviation Cessna 550 Citation II G-ESTA. (Peter Turner)

Peter Turner celebrated 100 years of aviation on 17 December 2003 by flying ten different types of aircraft in one day. The first was this Scheibe Rotax-Falke (G-KWAK), followed by a Shempp-Hirth Discus glider (Glider - W3), and a Fournier RF-4 (G-AVHY). (Peter Turner)

Then a North American Harvard IIB (G-DDMV), Cessna Citation II (G-ESTA), this Bell Jet-Ranger III (G-HEBE), a Stampe (G-FORC), a Beech Baron (N503BA), a Emeraude (G-SAZZ) and finally the Cessna 172 (G-ASSS) in the background. (Peter Turner)

One of the twenty-three Eurocopter EC135 helicopters provided for both police and ambulance operations, outside their base with the three Bolkow BO105 helicopters, which serve mainly as backup aircraft. (Dave Haines)

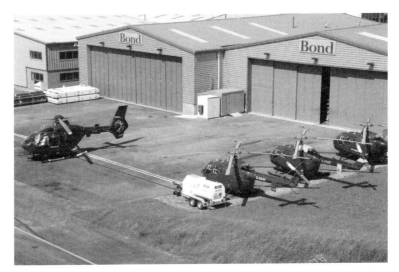

To address the need to ensure crews are prepared for any inflight emergencies, Bond Helicopters invested £1.6 million creating the world's first EC135 simulator, housed in a fully equipped training facility. (Bond)

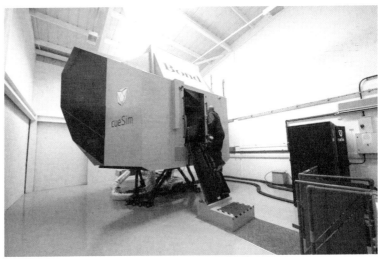

The simulator's highly detailed graphics generated from aerial photographs and sophisticated technology provide a realistic low-level flying capability. (Bond)

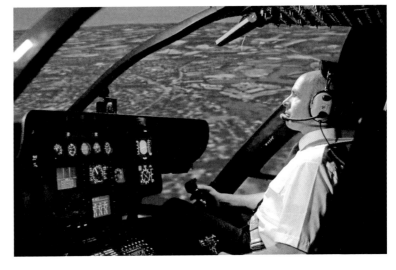

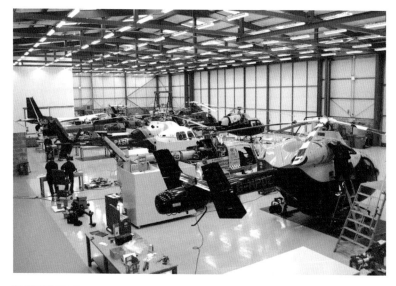

A view of Specialist Aviation's busy maintenance facility where in-house engineers have designed and installed specialist police and ambulance equipment into the latest MD902 series helicopters. (SAS)

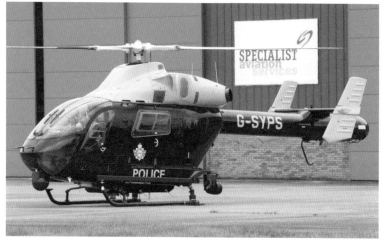

Police MD 902 Explorer G-SYPS at the SAS facility 2013. (Dave Haines)

Cirrus SR22T N648AB outside RGV, a family run aircraft and avionics maintenance business established in 1973, which is regarded as one of the world's top Cirrus service centres. (Dave Haines)

Gloucestershire Airport

In 1993, Staverton was renamed Gloucestershire Airport to reflect its increasing prominence as the business aviation centre for the county. Today it is a thriving business and recreational airport, handling around 85,000 movements each year. It has become the eleventh busiest airport in the UK. Its location, facilities and three runways provide the perfect site for aircraft from the Tiger Moth, the ATR42 and the PA-28 to the Dassault Falcon.

It is an important focus for aviation-related employment activity in Gloucestershire. Within the airport precinct, around forty aviation-related companies rent premises. On the north side, the Meteor Business Park contains a range of companies, employing some 2,500 people, including large aviation-related firms such as Messier-Bugatti-Dowty and Dowty Propellers. It also provides a wide range of recreational and private flying activities.

Around 180 aircraft are permanently based at the airport, ranging from single-seat microlights to multi-million dollar executive jets. Approximately forty air ambulance and police helicopters, serving about 75 per cent of the UK's forces, are operated by Staverton-based companies. It is also used by medical flights that support hospitals in the region.

A wide variety of specialist tasks, including aerial survey, monitoring and photography, routinely take place from the airport. In addition, the airport's pilot training facilities support operations at the region's larger airports, helping to ensure a supply of pilots for the growing number of commercial flights operating there. The aircraft maintenance operations and maintenance training facilities based at Gloucestershire Airport also support the aviation sector generally in the region.

More than thirty companies based in the area regularly use Gloucestershire Airport for corporate aircraft or air-taxi services. Almost all the 100 air-taxi operators in the UK use this airport to connect the Gloucestershire area to other parts of the UK and Europe not directly served by scheduled services.

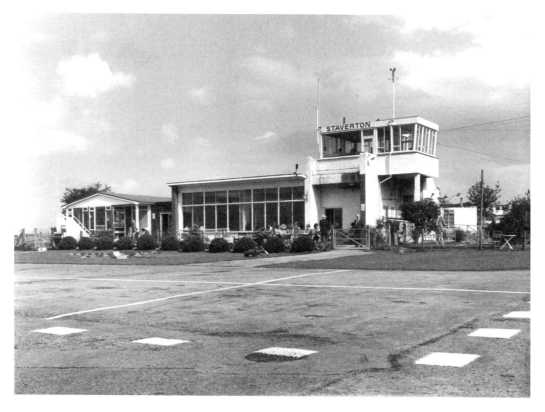

The 1970 terminal. (Eddie Faulkner)

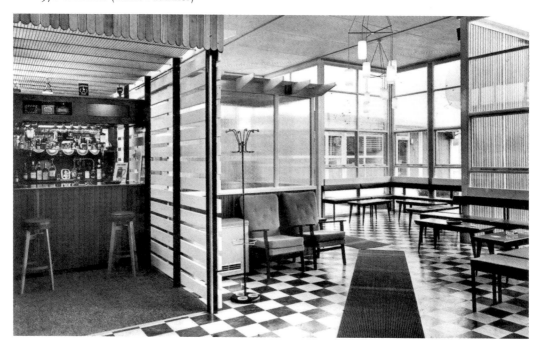

The interior in the same year. (Lavina Holmes)

The original terminal centre, far left, with a wartime hangar, centre. (Darren Lewington)

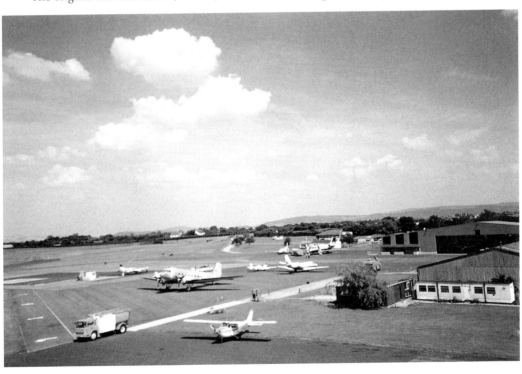

In recent years older buildings have been replaced by modern, professional, efficient facilities. A new passenger terminal, centre right, was opened in 2000. (Lavina Holmes)

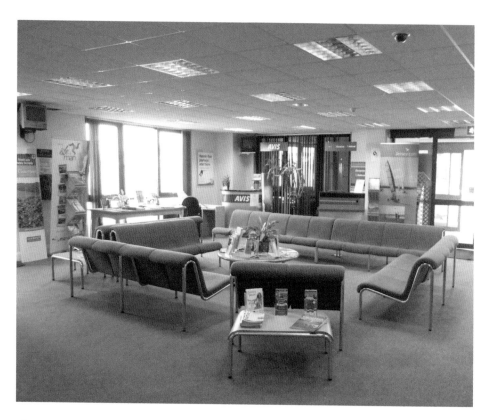

The 2013 interior, equipped with car hire desks, refreshments and TV. (Guy Ellis)

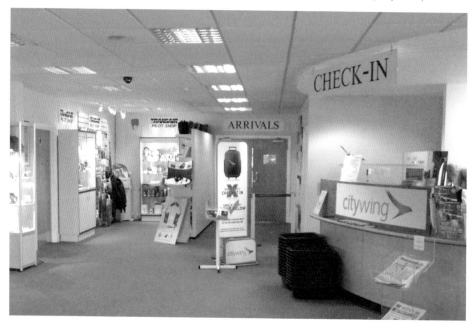

Passenger services have everything found at a major airport: a small shop, baggage scanner, and an arrivals hall with Customs Control but with free parking. (Guy Ellis)

Hangar SE3, built in 1941, was refurbished in 2012. The steel frame was found to be in exceptional condition; new glass doors and office facilities bring the old hangar into the twenty-first century. Compare this view with those of the Smiths fleet photographs. (Dave Haines)

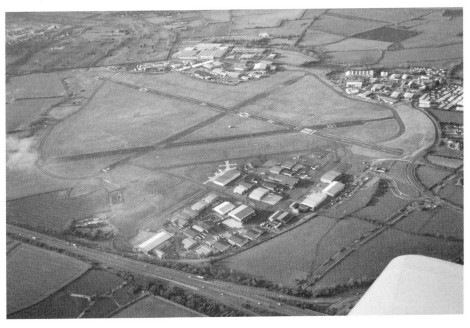

Gloucestershire Airport Ltd manages the airport and has a ninety-nine-year lease on the 400-acre site. It is wholly owned by the Gloucester City and Cheltenham Borough councils, and trades as a normal profit-making business contributing directly to local authority revenues. Compare this with the same view during the war years. (Darren Lewington)

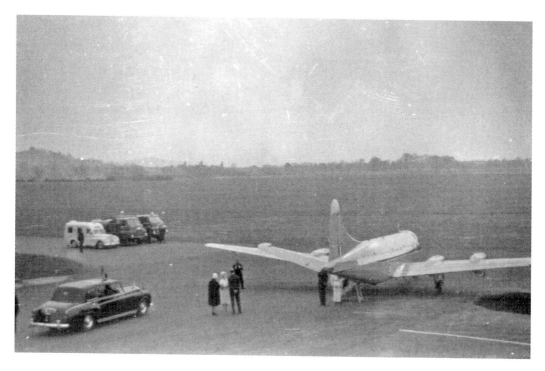

Most members of the Royal Family have used the airport. The Queen Mother is about to board a DH Heron of the Royal Flight in the 1960s. Note the emergency vehicles. (Eddie Faulkner)

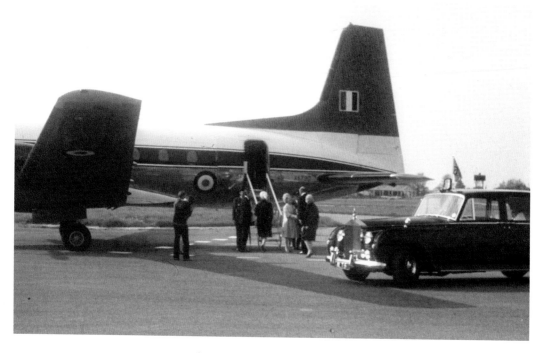

On another visit the Queen Mother is boarding an HS 748 Andover in 1974. It would appear the same Rolls-Royce was used. (Phil Mathews)

ZE701, a BAe 146-100 CC.2. of the RAF Queen's Flight, March 2013. (Darren Lewington)

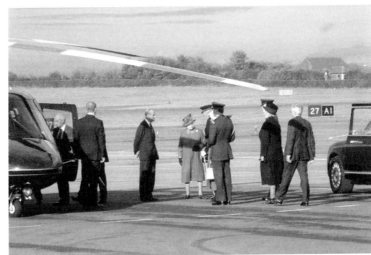

The Queen and Prince Philip landed at Gloucestershire Airport aboard Sikorsky S-76C G-XXEA.

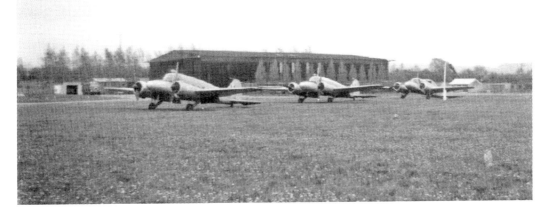

The RAF frequently visits Gloucestershire. These Ansons brought personnel for a meeting at RAF Innsworth in the early 1960s. (Eddie Faulkner)

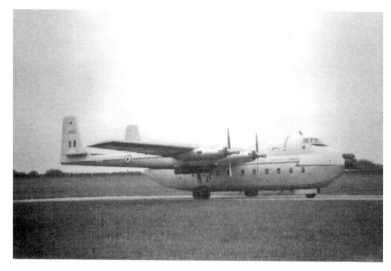

This Armstrong
Whitworth 660
Argosy C.Mk.1 was
on air show duty.
(Eddie Faulkner)

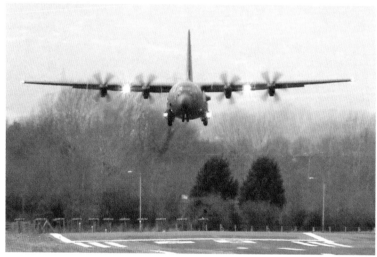

In this case, a C130
Hercules is on a
training excercise.
(Darren Lewington)

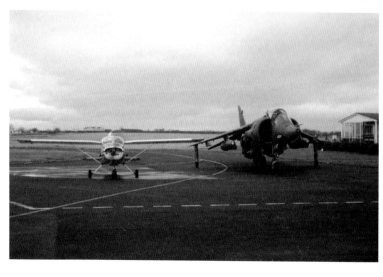

Cotswold Aero
Club Bolkow 208
and Harrier. (Phil
Mathews)

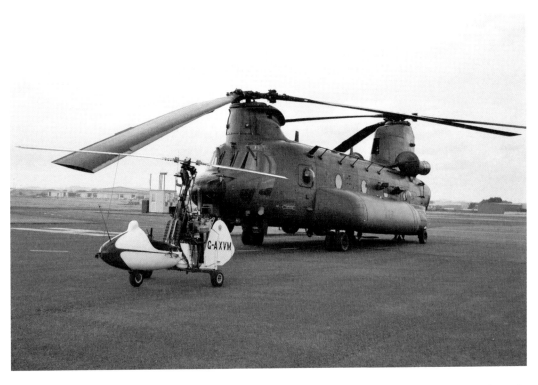

1970 Campbell Cricket Autogiro G-AXVM, a resident since 1981, poses with a visiting Chinook. (Darren Lewington)

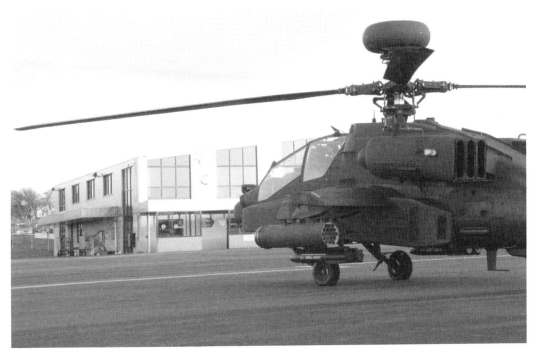

Apache ZJ168, December 2012. (Dave Haines)

There are always interesting visitors at the airport. Boeing B-17 Flying Fortress 485784 performed an air display in the mid-1970s. (Peter Gledhill)

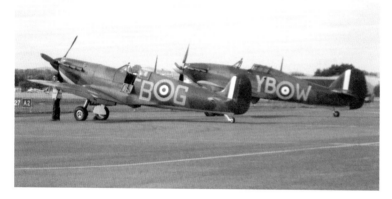

The Battle of Britain Memorial Flight Spitfire Mk IIa, P7350, the oldest airworthy example, and Hurricane Mk IIc LF363, the last one to enter RAF service, visited on 15 September 2011. (Dave Rose)

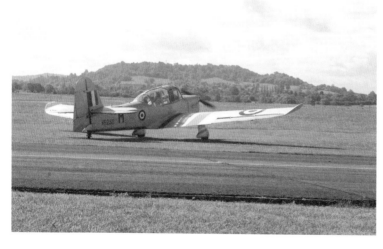

Air Atlantique Percival Prentice VR259/G-APJB providing flips at a Jet Age Open Day in 2011. (Guy Ellis)

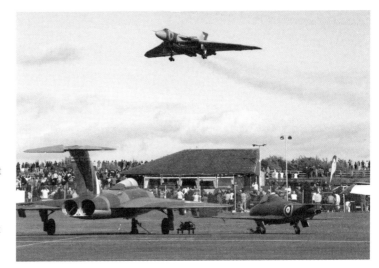

Fitted with Smiths instruments and Dowty undercarriage, Avro Vulcan XH558 performed a flypast in September 2012 as part of its Diamond Jubilee tour when it flew over locations relevant to the type's development and service life. (Dave Haines)

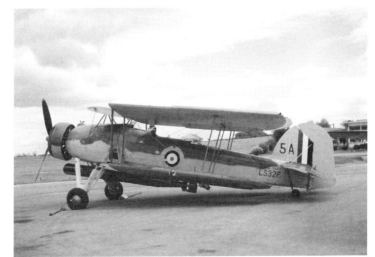

Visiting in probably the late 1970s is Fairey Swordfish LS326 of the Royal Navy Historic Flight. (Phil Mathews)

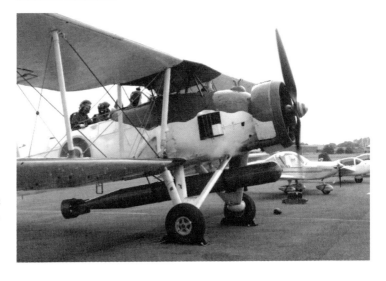

After a technical stop in September 2013, LS326, which saw active service on North Atlantic convoy duties, was photographed preparing for takeoff. (Guy Ellis)

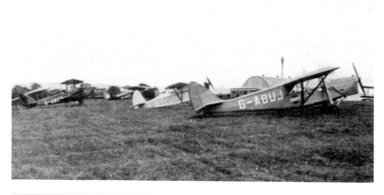

Rallies and displays have always been popular. An air rally at Down Hatherley. (Phil Mathews)

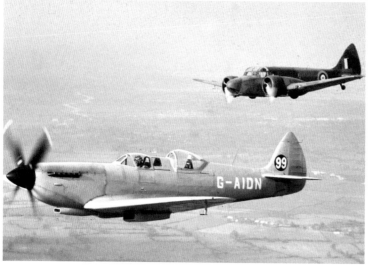

The roads around the airport were crammed for the 31 March 1968 50th Anniversary RAF Airshow. John Fairey is seen here in his two-seater Mk.VIII Spitfire, G-AIDN, in formation with Skyfame Oxford. (Phil Mathews)

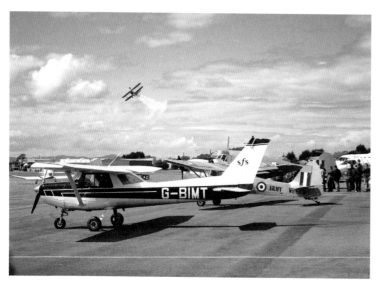

This view of the 2011 Open Day shows the SFS Cessna 152, WE569 Beagle A.61 Terrier 2, G-ASAJ and Avro Anson T21. Above them is a wing-walker display aboard a Boeing Stearman. (Darren Lewington)

The south side of the airport in 1969. Centre top is hangar SE3, ex-Smiths, now Direct Aviation; the silver one is GlosAir; the one opposite SE2 was Flight Refuelling; and SE1 was home to the Skyfame Museum, with their Hastings, Avro York and Sea Venom parked alongside. This was demolished for the new terminal. (Malcolm Payne)

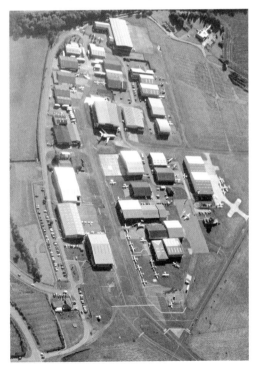

The same area in 2013. The large white jet is parked outside SE3, with the old Glosair hangar in front. (Darren Lewington)

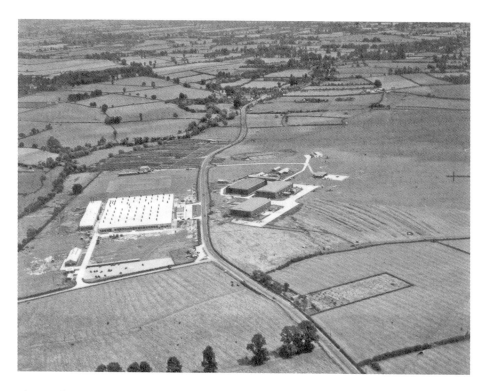

The north side of the airfield in 1940, showing the Rotol buildings and the wartime hangars. (Roger Smith)

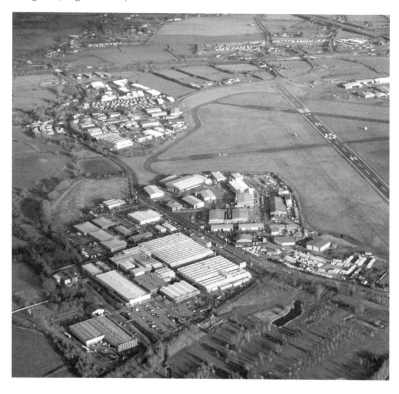

The same view in 2013. (Darren Lewington)

The Museums

Skyfame

On 12 July 1941, a Vickers Wellington IC Z8775 of 15 Operational Training Unit (OTU) lifted off the airfield at Luqa, Malta, on a ferry flight to Egypt. Shortly after, it crashed near Safi, killing all on board.

One of those who perished was nineteen-year-old Sergeant Desmond Thomas, the son of David and Eleanor Thomas, of Pantgwyn, Cardiganshire. Buried at Malta's Capuccini Naval Cemetery, and with a memorial window at St Mary's Church, Cardigan, his greatest memorial is the British aircraft preservation movement.

In 1963, Peter Thomas, poultry farmer and aviation enthusiast, established the Skyfame Museum in memory of his older brother Desmond, gathering together a collection of aircraft which became the stimulus for the popular business of preserving rare aircraft. Peter and his wife Gwladys were able to make quick decisions and take prompt action to save the valuable aircraft threatened with scrapping.

The museum was offered accommodation in 1963 by Ray Darby, the manager of the Gloucester/Cheltenham Municipal Airport. The first aircraft to take up residence was the last flying wartime version of the Avro Anson, N4877.

In *Flight International* of 9 January 1964, Thomas laid out his pioneering plan to preserve 'within the British Isles, as many as possible of the famous British aircraft used in the Second World War'.

A group from the British Aircraft Corporation (BAC) had found the only surviving pre-war Miles M.14A Hawk Trainer III, G-AFBS, in very poor condition behind a hangar at Bristol Airport. Led by Graham Johnson, they offered to restore the aircraft and in turn Skyfame agreed to purchase the completed airframe, which was delivered 16 October 1965. By this time, the museum, housed in half of T2 hangar SE1, held aircraft that covered all the Commands of the Royal Air Force and the Fleet Air Arm.

The annual Skyfame air shows were very popular, but keeping the collection airworthy was a constant battle. Peter described to the readers of *Flight International* of 21 September 1972 how the Anson had been restored to flying condition: 'Faced with this considerable and costly task, Skyfame approached the makers, Hawker Siddeley Aviation, and the Rolls-Royce Bristol Engines Division at Filton, with an appeal for assistance. The response was immediate and sympathetic.' These two companies, supported by fellow Staverton residents, Dowty, Glos-Air, Flight One and the airport management, completed the restoration to flying condition.

By the mid-1970s the buying and selling of classic aircraft was seen as a booming and profitable business and the airport authorities increased the rental on the Skyfame hangar, which made the museum no longer viable and it was forced to close.

In spite of the ever-present restrictive military and civil bureaucracy, Skyfame managed to save at least nineteen aircraft; all of them are now rare treasures in other collections.

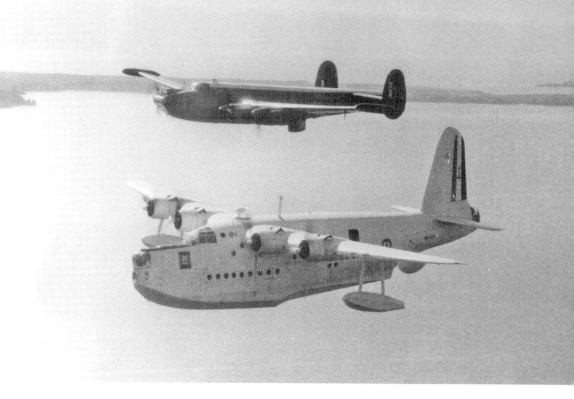

The Skyfame idea began after Peter Thomas raised £15,000 from the public to preserve an RAF Sunderland flying boat. Rejected by the RAF, he approached the French Navy who donated one of three based on Toulon. Escorted by two Avro Shackletons from 210 Squadron Coastal Command, her old Squadron, flying boat ML824 arrived at Pembroke on 24 March 1961, to be greeted by a large crowd and the siren salutes of every ship in the harbour. Presented to the Short Sunderland Trust she remained as a memorial to wartime aircrew until March 1971, when she was transferred to the RAF Hendon Museum. (Ray Thomas)

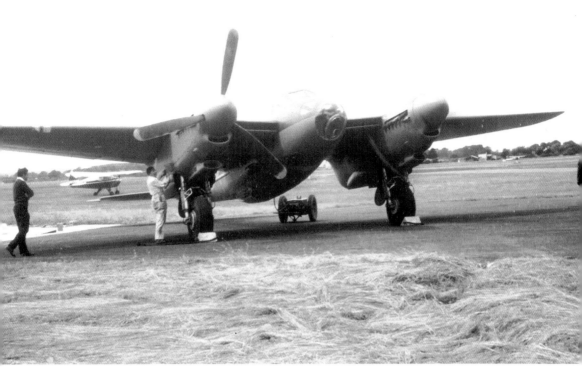

Staverton fireman Brian White prepares to start the starboard engine of DH Mosquito TA719 'Georgie' in mid-1964. Acquired on 31 July 1963, after retirement as a target tug, it was immediately put to work in the film *633 Squadron*. It was meant to be the star at the museum's opening but it was only on 16 October 1963 that David Ogilvy delivered the popular 'Wooden Wonder' after its release by the film company. (Ray Thomas)

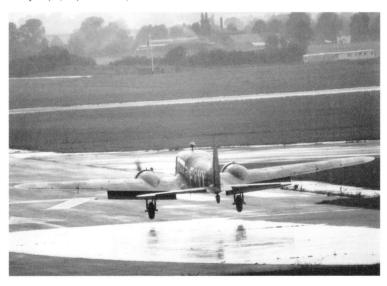

Avro 652A Anson 1 N4877 is landing at Staverton after a flying display. Built by Avro at Chadderton in late 1938, it served as a transport aircraft with the Air Transport Auxiliary. Registered G-AMDA in 1950, it arrived at Skyfame in 1963 where it was repainted as N4877, with code letters 'VX-F' of 206 Squadron RAF Coastal Command. (Ray Thomas)

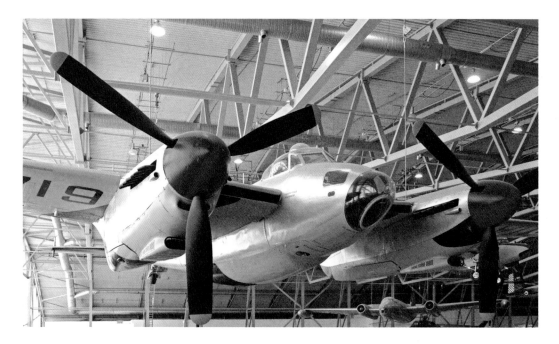

During the summer of 1964, a commercial pilot practising for a display in the Mosquito feathered one engine, but then radioed the tower reporting double engine failure. Fortunately the pilot managed to perform a wheels-up landing, but the aircraft was severely damaged and never flew again. It remained as a static display and did appear in the 1968 film *Mosquito Squadron*. It now has pride of place at IWM Duxford. (Tony Hisgett)

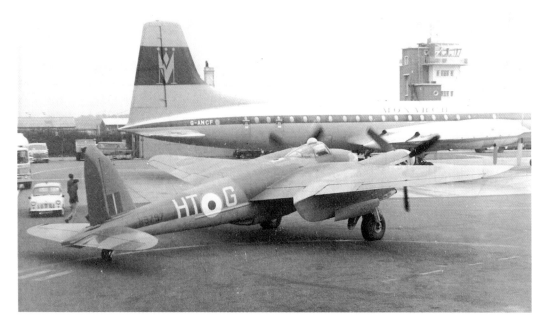

Another star of *633 Squadron*, RS709, arrived as a replacement in September 1964. This aircraft was also in '*Mosquito Squadron*' at Bovingdon. It is seen here at Luton Airport preparing to depart England for Harlingen, Texas, in December 1971. (Ray Thomas)

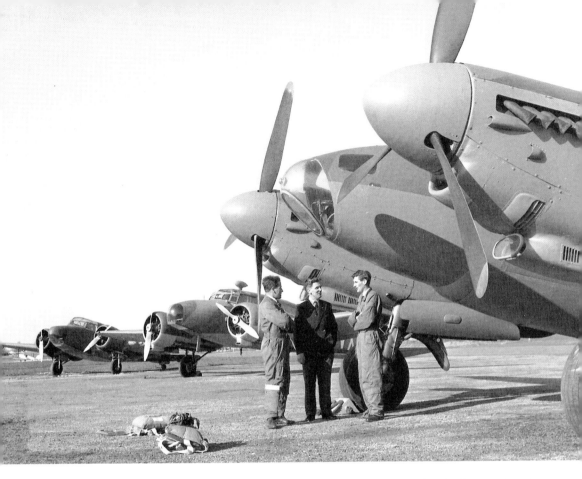

John Schooling, Peter Thomas and David Ogilvy pictured with Skyfame's three twins, the Airspeed Oxford, Avro Anson and DH Mosquito, after one of the open days. (Ray Thomas)

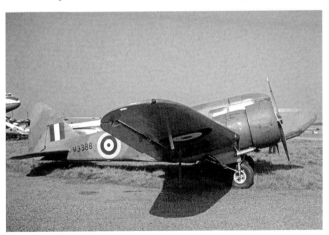

A most significant addition to the collection in 1963 was Airspeed Oxford V3388, which represented the aircraft on which Desmond Thomas had won his wings at Brize Norton. Previously Boulton-Paul's hack aircraft G-AHTW, it is shown here at Staverton in 1971. (Alan Scholefield)

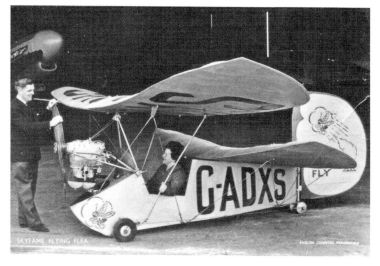

In 1963 this 1937 Flying Flea was loaned to the museum by Mrs Gwen Story, from Southend-on-Sea, following the death of her husband, who had told the *Glasgow Herald* that 'I consider anybody who can drive a car can fly one of these machines'. (Ray Thomas)

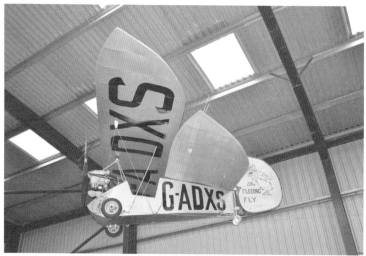

G-ADXS is now at Breighton Airfield with the Real Aeroplane Company. (Andy Wood)

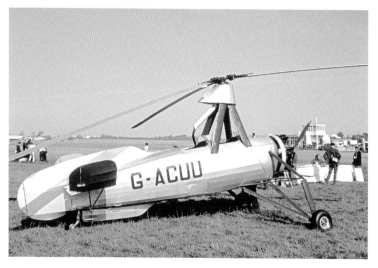

Also on indefinite loan was Guy Baker's Cierva C.30A Autogiro G-ACUU. Built by Avro at Woodford in 1934 and impressed as HM580, it was flown post-war until withdrawn from use in 1960. It is pictured here at a Skyfame Day, Staverton, 1971. (Alan Scholefield)

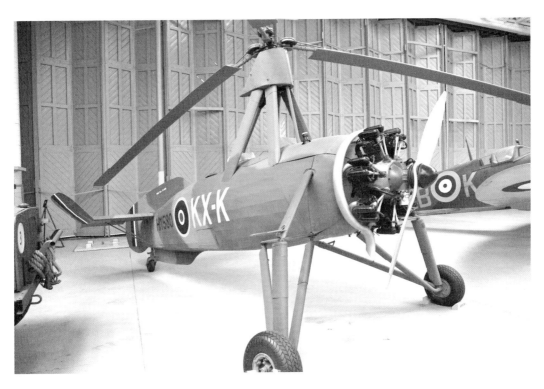

It moved to Duxford in early 1978 and was displayed in wartime colours. Autogiros were used by the RAF to check and/or calibrate radar stations as they were able to fly in very tight circles. (David Merrett)

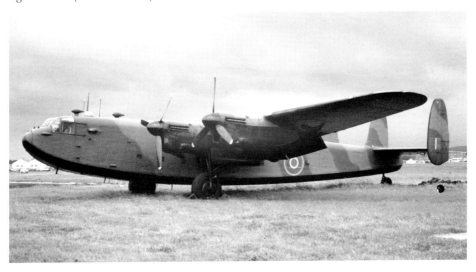

Peter Thomas re-mortgaged his house to raise the £600 necessary to save the last flying Avro York, G-AGNV. Flanked by two Handley Page Hastings of 24 and 36 Squadrons, the York and her escort made three flybys before making her final landing on 9 October 1964. In the following spring a team from Avro/Hawker Siddeley, Woodford, spent two weeks re-spraying her in wartime camouflage and the markings of LV633 'Ascalon', representing the VIP transport aircraft used by the King and Churchill. (Keith C. Wilson)

Three of the Skyfame collection around 1969. From left to right: Handley Page Hastings C.1A TG528; de Havilland Sea Venom WM 571, built at Christchurch in 1954, purchased by the Skyfame Supporter's Society and presented to the museum on 30 April 1969, now with Solent Sky Museum; and Avro York TS798/G-AGNV, now at RAF Cosford. (David J. Smith)

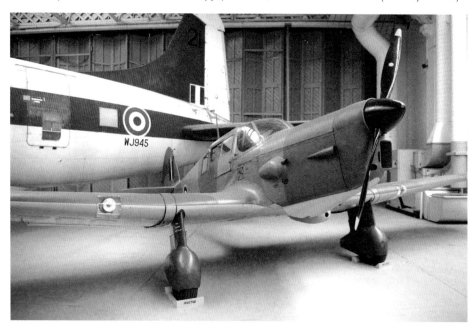

Percival Proctor Mk.III LZ766/G-ALCK, now at Duxford, was saved by a group from the Royal Observer Corps at Tamworth in Staffordshire. Led by Chief Observer Thompson and Leading Observer David Peace, they restored it, after months of hard work, to a presentable static state and then donated it to the Skyfame Museum. It was delivered to Staverton on 23 February 1966, and painted in wartime camouflage by Skyfame's volunteers. It was used as one of the first hands-on exhibits in the world. (David Merrett)

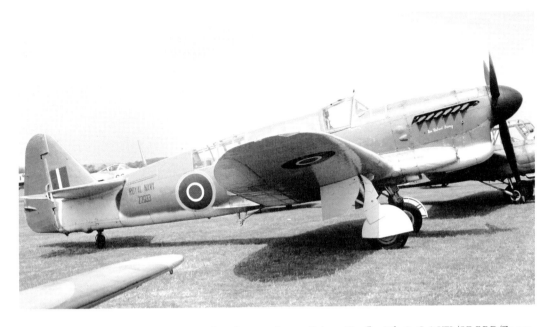

Soon after the 1964 Easter weekend open day, a Fairey Firefly Mk I, G-ASTL/SE-BRD/Z2033, was delivered by Tage Palle and engineer Kenneth Skold. The ex-Royal Navy aircraft had been donated by Svenska of Stockholm, where it had been used for target towing. On display at Duxford since 1978. (Keith C. Wilson)

Peter and Gwladys holding models of the SARO and Tempest in 1966, having received confirmation that the airframes had been donated by the College of Aeronautics, Cranfield. (Ray Thomas)

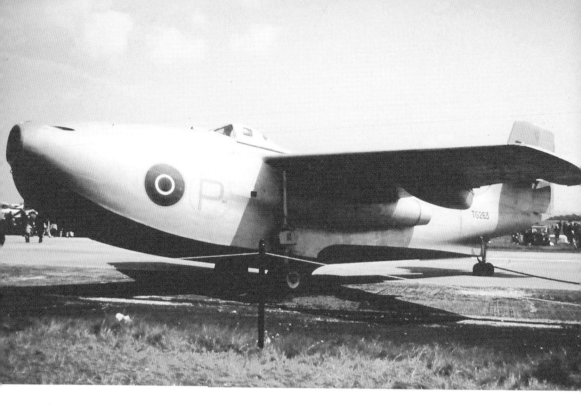

The unique Saunders Roe SARO SRA1 jet fighter flying boat TG263, at Skyfame in 1969. (Roger Wisner)

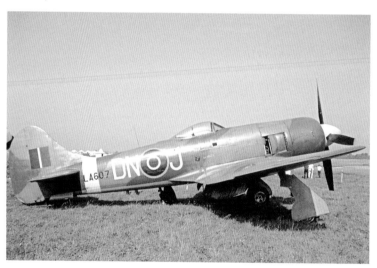

The Tempest Mk2 LA 607 prototype, powered by a Bristol Centaurus radial engine, at Staverton in 1971. It is now preserved at Lakeland, Florida. (Alan Scholefield)

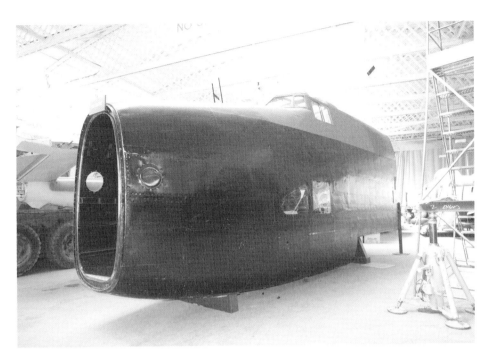

Graham Trant and Harry Levy saved the nose section of the very last surviving Handley Page Halifax, PN323, which they delivered to Staverton in November 1966. Post-Skyfame, it became a walk-through exhibit at the Imperial War Museum for many years before being put into storage at Duxford. (Brian Marshall)

Three ex-Skyfame aircraft can be seen in this view of the Airspace hangar at Duxford. Suspended is the Oxford, bottom right is the Anson and obscured behind is the Miles Magister. (David Merrett)

Jet Age Museum

A public meeting was called in Cheltenham in 1986 to discuss setting up a museum devoted to the county's world-class aviation heritage. By August the name Gloucestershire Aviation Collection had been adopted and a feasibility study carried out for a new building at Staverton.

These plans were dropped in 1992 when redevelopment of the former Gloster Aircraft Company's factory airfield site resulted in the developers donating the use of a hangar. Proposals were made to incorporate the rebuilt Gloster control tower as the centrepiece of a new museum.

The first museum aircraft, Meteor T7 WL360, arrived from RAF Locking, on loan from the Ministry of Defence, while a Friends organisation began work on a replica 1925-vintage Gloster Gamecock biplane fighter.

Javelin FAW9 XH903, the former RAF Innsworth gate guardian, on loan from the MoD, arrived in 1993, followed by Hunter T7 N-315, the forward fuselage of Harrier T2 XW264 and Sea Venom FAW22 XG691. The following year saw the formalisation of the museum with management and friends combined into a single membership organisation.

More aircraft arrived in 1995: Hunter F5 WP190, bought by a member for restoration; Buccaneer S2B XX901, owned by the Buccaneer Aircrew Association; the forward fuselage of Buccaneer S2B XV165; Meteor F8 WH364, donated by one of the museum patrons; and Canberra TT18 (formerly B2) WK126. Components of Typhoon, Gladiator and Albemarle aircraft were acquired, as well as significant archive material, and the first-ever reunion was held for former Gloster Aircraft Company workers.

The redevelopment of the trading estate meant that GAC was obliged to move out at Easter 1996, finding a new home in half of Hangar 7 at Staverton. Jet Provost XS209 and the cockpit of Lightning XG331 arrived, but by now the two Hunters and Buccaneer XX901 had moved on.

It was decided to concentrate on building a core collection of Gloster aircraft. Meteor T7 WF784, the RAF Quedgeley gate guardian, was bought with a grant from Tewkesbury Borough Council, allowing the T7 WL360 to be returned to the MoD, while Meteor NF14 WS807 was donated. The remainder of Hangar 7 was taken over in January 1997 and the Vulcan nose section XM569 and Buccaneer S2B XX889 arrived.

The initials GAC had been chosen to echo those of the former Gloster Aircraft Company but both the name and the initials caused confusion rather than clarity and in 1997 the name Jet Age Museum was adopted. This commemorates the design, building and flight of the first British jet, built by Glosters, when the Gloster E28/39 became airborne at Brockworth aerodrome on 8 April 1941.

In 1998 Vampire T11 XD506 was donated by a local company and the basic fuselage of the Gamecock reproduction moved to Staverton to be unveiled by Ida Whitaker, daughter of Gloster Aircraft Company founder A. W. Martyn, on her 100th birthday.

A Jet Age team visited Norway for the first of a series of visits, recovering wreckage of RAF Gladiators from their 1940 crash sites. Jet Age volunteers have worked on four Gladiator rebuilds and work on N5914 for the museum's own collection is on-going. The forward fuselage frame of a Typhoon arrived and a member bought Anson C19 VM325. 1999 saw the arrival of two cockpits, Hunter XE664 and one of the earliest surviving Meteors, Mk III EE425.

Jet Age Museum's wilderness years began in 2000 when the chairman died in office and notice was received to quit Hangar 7. The Airport offered a site for a new museum building in

2002 and planning application was approved, while storage and workshop space was offered in former agricultural buildings at Brockworth Court. Jet Age took on the management of the photographic collection of the late Russell Adams FRPS, Gloster's chief photographer and the pioneer of jet air-to-air photography.

2007 was a landmark year, the centenary of the birth of Frank Whittle, and the E28 replica was rolled out at the first open day since leaving Hangar 7. Repeated applications for Heritage Lottery Fund assistance had proved unsuccessful but, determined to survive, the museum sought pledges to fund a downsized building at Staverton. Tewkesbury Borough Council pledged 10 per cent of the project cost, to a maximum of £27,000, and major donations were received from the BVG Clarke Will Trust, Rolls-Royce plc and the museum's own members. In February 2011 planning consent was granted for the new building on a two-acre site donated by Gloucestershire Airport.

Open days were held at Brockworth for visitors to see the E28 replica, the nearly-completed reproduction Gamecock and the early stages of restoring the Typhoon cockpit. In late 2011 Gary Spoors of GJD Services donated a rare Meteor NF13, WM366, which had served with the Israeli Air Force as 4FXNA.

In early 2012 some of the aircraft were moved out of storage and returned to Staverton and a Buy a Brick campaign was launched to raise money for the new building, and after some delay construction of a permanent home was finally under way. Simultaneously the F8 was under restoration, and plans for a replica Horsa WW2 invasion glider cockpit were launched. After a remarkable cooperative effort by local companies and the museum's own volunteers, Jet Age at last opened the doors of its permanent home.

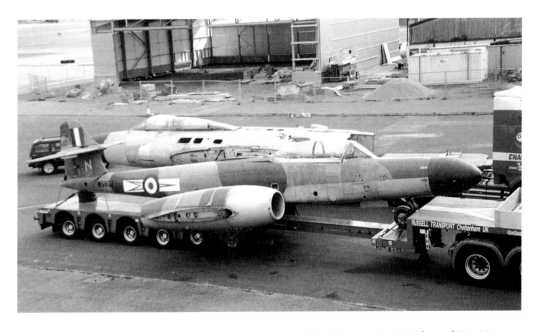

In 2000 aircraft and archives went into storage, some with local companies Smiths and Van Moppes, others at the former Gloster factory at Bentham. With the sale of the Bentham site these aircraft moved to external storage at Staverton and the former RAF Quedgeley. (Lavina Holmes)

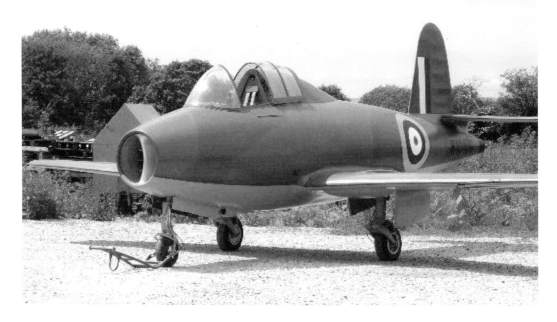

Former colleagues of Sir Frank Whittle, the Reactionaries, joined with Tewkesbury Borough Council to pay for a set of mouldings to construct an external replica of the Gloster E28/39. It has since appeared to great acclaim at a number of public engagements. (Jet Age)

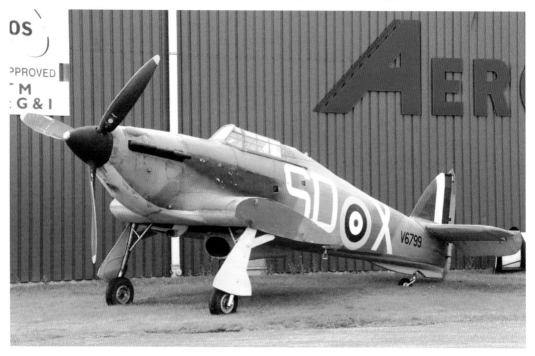

Members bought a replica Hurricane, used in the 1969 film *Battle of Britain*, which has been restored in the markings of a Gloster-built aircraft, V6799, serving with 501 (County of Gloucester) Squadron in the Battle of Britain. (Dave Haines)

The Vulcan cockpit has been on display at the Flying Shack flying school, raising funds for the new museum where it is now located. (Darren Lewington)

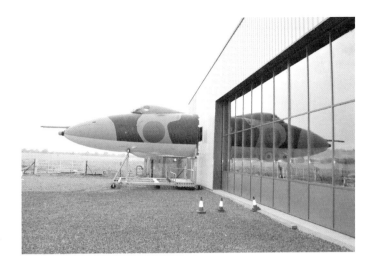

Two Jet Age members bought Meteor T7 VW453, the former RAF Innsworth gate guardian, which was delivered to the Airport by Chinook ZA674 in April 2013. (Liam Daniels)

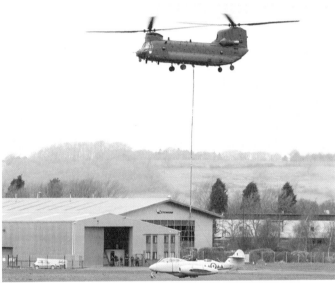

The Jet Age Museum, a registered charity, opened its new permanent home at Staverton on 24 August 2013 with a series of preview days ahead of the official opening in 2014. Years of dedicated effort had finally secured the collection's future. (Darren Lewington)

References

Publications

Davies S. R., *RAF Police Dogs on Patrol* (Bognor Regis: Woodfield
 Publishing)
Gloucestershire Airport Information Gloucestershire Airport, 29
 March 2008
James D. N., *The Flying Machine in Gloucestershire* (Stroud: Tempus
 Publishing, 2003)
Moyes P. J. R., *Air Extra Number 7* (Shepperton: Ian Allan, 1975)
Smiths Industries, *Smiths Industries at Cheltenham* (Oxon: Kristall
 Productions, 1990)
Stait B. *The History of an Airscrew Company* 1937–1960 (Rotol)

Websites

www.airfieldinformationexchange.org
www.flightglobal.com
www.glostransporthistory.visit-gloucestershire.co.uk
www.gloster.pwp.blueyonder.co.uk
www.rafmuseum.org.uk
www.sonsofdamien.co.uk
www.nationalmuseum.af.mil

Unpublished notes

Cotswold Aero Club Minutes and Notes

Acknowledgements

Thank you to all the photographers who so generously provided their
images, their time and knowledge. Without you there would be no
publication. I would like to thank the following for their advice and
assistance: Jack Abbot, Roxy Base, Phil Butler, Tanya de Leersnyder,
Alan Drewett, Eddie Faulkner, Dave Haines, Tim Kershaw, Darren
Lewington, Jennie Lyons, Malcolm Payne, Phil Mathews, Kenneth
McGillivray, Peter Turner, Ray Thomas and Peter Walwin.